Introduction
by Jacqueline Francis and Jeanne Gerrity

JF: Lorraine O'Grady's art and writings generate a lot of questions. Some are vast inquiries—worth asking, but impossible to definitively answer: What should artists do? Does art make a difference? Others seem narrower, albeit grounded as they are in historical and contemporary problems, such as exclusion, marginalization, and inequity. Lorraine has long sought to persuade us that these are not minority issues, but instead systemic and institutional messes that affect everyone.

JG: I think that's a really important point. Lorraine addresses issues in her work that are universal, and people are finally realizing that they need to be confronted in order for us to move forward as a society. There was a moment this past spring when I know a lot of people, including me, felt deep despair. We were learning to live with a global pandemic, when ten Black people were shot by a white supremacist in Buffalo, NY, less than two weeks later twenty-one people were killed in a school shooting in

1

Uvalde, TX, and a month after that the Supreme Court overturned the constitutional right to abortion. At the Wattis we were in the final months of the Lorraine O'Grady research season and just beginning to think about this publication. These projects propelled me forward, and Lorraine's nuanced, sophisticated approach was motivating. Her work bridges divides, but it never compromises. It doesn't shirk anger, but it also strives for joy.

JF: Cutting through the hilarity of the *Mlle Bourgeoise Noire* performance is impatience and a streak of anger: some of what's happening in this artwork is communicated frustration with the status quo. Reading closely, we pick up the same kind of exasperation of Édouard Glissant's essay "For Opacity." Here, he writes against "Western thought" that reduces and diminishes the Other. Charles Lee's *Destiny Manifested I, II, III, IV*, Erica Deeman's *Inner Eye*, and Selam Bekele's *Empty, Whole, and On the Way* offer corporeality that rejects overdetermined readings. In Lorraine's writings and projects, it's clear that she has had it with garden-variety essentialism that's a byproduct of exclusion, discrimination, and elitism in the contemporary art industry as well. She also challenges Black artists to make

work that calls out inequity. What I hear in *Mlle Bourgeoise Noire*'s exhortation to everyone who politically identifies as Black "to take more risks" is that we "stop playing nice" in order to get ahead.

JG: Completely. I see that in the work of E. Jane, who calls out the lack of media representation of darker skinned Black women, and Alisha B Wormsley, who uses photography and text to think about the relationship between Black women and their environment. In an excerpt from her book *Glitch Manifesto*, Legacy Russell confronts the history of excluding Black women in the feminist movement, and of course Linda Goode Bryant, the founder of Just Above Midtown, is the epitome of making things happen without asking permission first.

JF: Lorraine's work and that of the artists and writers who are contributors to this volume express resistance to censorship and attempts to silence. Bec Imrich, for one, starts off her essay with divulgement: the move is an insistence that family histories and traumas must be discussed. Gabrielle Civil's essay also reveals: What are the presumptions formed around the performance artist's body and what can

3

be said out loud about it? The launching point of my essay was a photo of Lorraine and the singer Johnny Mathis taken in 1974. At the time, Mathis's queerness was an open secret. As a phrase, "open secret" registers as an oxymoronic contradiction and yet it is one that functions and communicates an idea. There's a push-pull dynamic here that's perhaps always present in the social sphere. "How does language drive?" is a question raised in Allison Yasukawa and Hsu Peng's transcribed conversation "Drive My Car."

JG: Many of the thinkers in this book challenge commonly accepted tropes, breaking down simplistic attitudes and adding nuance. In an excerpt from her academic article "Optical Illusions: Images of Miscegenation in Nineteenth- and Twentieth-Century American Art," Judith Wilson considers the prevailing North American focus on a rigid binary system of racial classification, and the relatively sparse artistic production and art historical analysis around the topic. In his seminal work *Black Athena*, Martin Bernal challenges the Eurocentric idea that civilization originated in Ancient Greece, instead offering compelling evidence that Egyptian and Phoenician culture provided the origins of the modern world. This theory is actually a

return to a previous model that was rejected in eighteenth century Europe as part of a general societal racism.

JF: Lorraine has always been interested in the politics of the archive and the construction of history. Research similarly drives Yétúndé Olagbaju's practice: Our cover image is her mixed media collage *For Edmonia*, an homage to the African American & Ojibwe sculptor Edmonia Lewis. Citing the neoclassical iconography that Lewis advanced, Olagbaju is troubling it. We see the historical impulse in Trina Michelle Robinson's ghostly prints of a newspaper clipping about one of her forebears—a Black American who passed for white. In *Museum Series*, Carrie Mae Weems is a somber figure confronting the edifices of institutionality, including the Louvre, Tate Modern, and the Philadelphia Museum of Art. Like Lorraine, Weems, Robinson, and Olagbaju intervene in received narratives in order to question them and revise them.

JG: Lorraine's inclination to complicate narratives may be connected to her own experience as a translator, both literally (she worked as a translator before becoming an artist) and

affectively and socially as she has moved through many communities throughout her life. In *Say Translation is Art*, Sawako Nakayasu also expands the traditional framing of translation, suggesting that it is inherently creative and even political at times.

JF: Returning to the use of historical references, Lorraine has long been fascinated by Charles Baudelaire and his muse, the Haitian-born Jeanne Duval, who was largely erased from history. Lorraine's interest in Duval was mirrored—trans-Atlantically—by that of the late Maud Sulter, a Scottish-Ghanaian artist and writer. In the late 1980s, Sulter began researching Duval, who inspired some of her mixed media collages in the 1990s and thereafter. In this book, we included aspects of another one of Sulter's late eighties projects: *Sphinx*, a series of nine haunting photographs shot in The Gambia. Sulter's consideration of place—a critical matter for her as her father was part of a twentieth-century African diaspora—is articulated in the first lines of her poem "Sphinx": "How do we construct a language to form the fabric of our lives?" The recovery of Duval has recently been furthered in Denise Murrell's *Posing Modernity*, a book of nineteenth-century Black women who were

cultural creatives as well as muses and models for the School of Paris artists. Duval sat for Manet, as did a Black woman named Laure. She is the focus of "Laure of Olympia," an excerpt from *Posing Modernity* presented here.

JG: Shifting the conversation a bit, I wanted to talk about how the fabric of Lorraine's life has been in New York City for decades. As a native New Yorker, I appreciate Jeanne Finley and John Muse's critique of the dog-eat-dog advertising world in *#BookReport*. At the same time, the community building in some of the city's cultural industries is no put-on. So many New York-based artists count Lorraine as a mentor and friend, and she's a vibrant presence on the scene. A short story by Kathleen Collins explores the intimacies of longstanding friendship among artists and writers, while Peter Simensky's contribution looks at the importance of collegial connections between artists.

JF: An under-considered aspect of Lorraine's biography is her Jamaican heritage. Her parents were Jamaicans who met at a cricket match in Boston in the 1920s. We take an excerpt from historian Lara Putnam's book on Caribbean migration to the United States; Putnam points

out that Jamaicans and Barbadians traveled to Boston and New York from as far back as the 1870s. By the 1930s, one-third of the Black population of Boston—Lorraine's hometown— were foreign-born people of African descent. We might consider this fact alongside Lorraine's many projects that address the pivot points of invisibility and visibility. Contemporary Jamaican artist Camille Chedda's drawing *Under Construction* brings scrutiny to that nation's dynamic dancehall music performances. She views them as empowering and imperiling acts for female dancers who break concrete blocks against their bodies, risking self-destruction.

JG: Music is a current that runs throughout this book. Lorraine herself began her career as a music journalist, reviewing early shows of Bruce Springsteen and Bob Marley. In *Rip It Up: The Black Experience in Rock 'n' Roll*, Darrell M. McNeill chronicles the birth of rock and roll, which was founded on racist attitudes that refused to acknowledge its origins in Black music. His accounting of the segregationist patterns of the commercial music industry is infuriating.

JF: We included an excerpt from David Scott's influential essay "That Event, This Memory: Notes on the Anthropology of African Diasporas in the New Word" because it is broadly concerned with how Black people across the globe have made use of the past as we create culture, conduct politics, and construct knowledge. Lorraine's projects are structured with such complexity and capaciousness. "This" doesn't only mean "that." The past isn't merely a script for the present nor is it a prospectus for the future. In her work, breaks and interruptions are generative and meaningful. They can't be jumped over or wished away. She insists that we go "through" them. As she herself has said, "you have to stand there and deal."

ドライブ・マイ・カー
在車上
Drive My Car
by 許芃 (Hsu Peng) and Allison Yasukawa

[*Driving*]

The Beatles:
Baby, you can drive my car
Yes, I'm gonna be a star

Allison YASUKAWA:
I've never liked the Beatles. And even though
Ryusuke Hamaguchi's film *Drive My Car* was
its own international sensation, I didn't like it
either. We don't need to get into why. The short
version might be that I don't particularly care
what men do without women. What's important
is that it's stayed with me—stuck rolling through
my head, like that Beatles song.

許芃 (HSU Peng):
Janice's Taiwanese accent in Mandarin does the
same thing to me. I ate sushi with it. I fell into
a dream with it. It makes me cringe. It's not

because of Janice; it's because of the Taiwanese accent in Mandarin. It drives me crazy. I can't believe that I might sound like that: so soft, so babyish—an infant and a hot girl, at the same time.

The Beatles:
Baby, you can drive my car
And maybe I'll love you

Allison YASUKAWA:
This is where our conversation started. Here is where it goes.

家福悠介 (KAFUKU Yūsuke):[1]
君は運転をどこで身につけた？
(Where did you learn to drive?)

Allison YASUKAWA:
How is driving a theory of directing?

柚原 (YUZUHARA):
あと、今回は私達の決まりでドライバーを用意します。家福さんのお車を運転させていただくので問題ないですか。
(We've hired a driver for you, according to our rules. So our driver will be handling your car; is that all right?)

家福悠介 (KAFUKU Yūsuke):
その件ですが、自分の車を自分で運転します。保険
にも入ってますし、お気遣いなくお願いします。
(About that, I'll drive my own car. I've got insurance. Please don't mind me.)

柚原 (YUZUHARA):
いえ、気遣いというか運転していただくわけにいか
ないんです。
(This isn't about hospitality, actually. We can't let you drive.)

許芃 (HSU Peng):
How does language drive?

Allison YASUKAWA:
What drives a performance?

許芃 (HSU Peng):
Does language drive reality—a reality which is one of many realities?

平田オリザ (HIRATA Oriza):
針對多樣的觀眾，一邊開啟多元語境共有的可能
性，同時展現自己的語境。這就是在現代演劇中，
寫作劇本時最大的困難根源。
(To address diverse audiences, one opens up possibilities for a shared multiple language context,

at the same time one presents one's own language context. This is the greatest source of difficulty in writing scripts for modern theater.)

許芃 (HSU Peng):

Hirata Oriza is a famous Japanese theater director and playwright popular among certain Taiwanese theater makers who are seeking a Taiwanese way of talking on stage. There is this tension between an imagined, pure Taiwanese-ness and a foreign Western-ness, which are—and should be—kept separate. The division isn't strict because, although people want to do localized plays, many of the plays they choose to localize are Western plays. So, for example, instead of Anton Chekhov's *The Cherry Orchard*, we get *The Cherry Orchard, Taiwanese Edition*. So the formula is: something from the West + a purposefully intentional Taiwanese flavor = The Right Way (PC). But this is just my opinion (I am nobody.), and I don't want to offend anyone. What matters is that I have the Mandarin translation of his book *Introduction to Engeki* (*Theater*), and I have done my own translation of his words here (with enormous help from Google).

高槻耕史 (TAKATSUKI Kōji):
家福さんの演出法は音さんから聞いていて、拝見

したかったんです。すごく変わってますよね、何カ
国語も。
(I'd heard about your methods and was interested. They're so different. Multilingual.)

許芃 (HSU Peng):
We're trying. We're trying to be multilingual here, but neither of us knows Japanese, and our Japanese friend is too busy for this project. He's taking care of his baby (Joe).

Allison YASUKAWA:
What drives language?

平田オリザ (HIRATA Oriza):
什麼是真實的台詞？
(What is a real line?)

許芃 (HSU Peng):
This is my translation of Hirata's core question. Another way of translating the question would be: What is a natural line? The introduction of Hirata's book is written by Lin Yu-Bon, a Taiwanese scholar who specializes in Japanese theater. In the following excerpt, Lin briefly introduces Hirata's thinking—and it would also be my translation (also with enormous help from Google).

14

林于竝 (LIN Yu-Bon):
平田認為日本的現代戲劇缺乏「真實性」, 跟日本
人的日常生活經驗有段距離, 而這個現象歸因於
舞台語言的問題。平田觀察到, 在日本的舞台上,
演員為了要表現情感, 加入了音樂性——一種充
滿抑揚頓挫的語言表現, 而舞台使用的語言是一
種只會出現在舞台上的文體。會出現這種奇怪的
文體, 是因為日本現代戲劇源自於西方, 藉由翻譯
西方劇本, 將現代戲劇的表現形式引進日本國內。
(Hirata thinks that Japanese modern drama
lacks "authenticity" and is far from the daily
experience of Japanese people. This phenom-
enon is attributed to a stage language. Hirata
observes that on the Japanese stage, actors add
musicality to express emotion—this language is
with cadence and happens only on the stage. The
strange style appears because modern Japanese
drama originates from the West. Through
translated Western scripts, the modern drama
expression was introduced to Japan.)

Allison YASUKAWA:
Can language be a bad driver?

許芃 (HSU Peng):
Oh, definitely; listen to Janice.

張珍妮絲 (CHANG Janice):
你瘋了？
(Are you out of your mind?)

Allison YASUKAWA:
But maybe it's not her fault.

許芃 (HSU Peng):
Je suis d'accord. The Mandarin *Uncle Vanya* script Janice is using already has an accent of translation. Can an accent of translation be translated? Can it be performed?

張珍妮絲 (CHANG Janice):
Of course, we'll follow all of your instructions, but we're not robots, and I think we'll do better if we know what your intent is.

家福悠介 (KAFUKU Yūsuke):
You don't have to do better. Just simply read the text.

許芃 (HSU Peng):
What are the differences between robots acting out a play and actors acting out a ritual? If you want a sense of ritual, does it inevitably demand a roboticness? What is the ritual Kafuku is aiming to create? Maybe it's a ritual of (forever) driving. But driving toward where?

家福悠介 (KAFUKU Yūsuke):
自分を差し出して、テキストに応える。
(Yield yourself and respond to the text.)

Allison YASUKAWA:
Yield = yellow light.

高槻耕史 (TAKATSUKI Kōji):
応える？
(Respond to it?)

家福悠介 (KAFUKU Yūsuke):
テキストが君に問いかけてる。それを聞き取って応
えれば、君にもそれは起こる。
(The text is questioning you. If you listen to it
and respond, the same will happen to you.)

Allison YASUKAWA:
How do we yield to language?

平田オリザ (HIRATA Oriza):
我認為所謂的演，歸根究底就是將自己的語境與
飾演對象的語境磨合起來。
(I think the most fundamental technique of
acting is being able to merge one's language
context with the character's.)

許芃 (HSU Peng):
But how? When the text also has layers and layers of other language contexts?

Allison YASUKAWA:
I think Kafuku would say it doesn't matter. Or that what matters is the way the rhythms of the languages drive the text.

家福悠介 (KAFUKU Yūsuke):
僕のやり方は、戯曲の流れを本当に全部頭に入れておく必要がある。だからうんざりするほど聞く。僕のリズムでセリフを言えば、ぴったり次のセリフがくる。
(The flow of the entire play has to be memorized with my method. So I listen to it over and over…. When I say my line at my pace, the next line starts precisely.)

Allison YASUKAWA:
Over and over. Tires rolling and rolling.

平田オリザ (HIRATA Oriza):
第五章 朝向「參與式的演劇」
(Chapter five, *Toward a Participatory Engeki* [*Theater*].)

許芃 (HSU Peng):
Drive toward.

공윤수: (KON Yoon-su):
彼女の運転はどうですか。
(How's her driving?)

家福悠介 (KAFUKU Yūsuke):
素晴らしいと思います。加速も減速もとても滑らかで、ほとんど重力を感じません。車に乗ってるのを忘れることもある。いろんな人の運転する車に乗ったけど、こんなに心地いいのは初めてです。彼女にドライバーを頼んでもらって、よかったといま思ってます。
(It's fabulous. She speeds up and slows down so smoothly, I hardly feel gravity. Sometimes I forget I'm in a car. I've experienced many people's driving, but it's never been so pleasant. I'm glad she was assigned as my driver is how I feel now.)

The Beatles:
Beep beep'm beep beep yeah
Beep beep'm beep beep yeah
Beep beep'm beep beep yeah
Beep beep'm beep beep yeah

許芃 (HSU Peng):
Or as a Taiwanese-accented Mandarin translation will go:

張珍妮絲 (CHANG Janice):
逼逼逼逼耶
逼逼逼逼耶
逼逼逼逼耶
逼逼逼逼耶[2]

[*Driving*]

Notes

1 Many thanks to Kensaku Shinohara for his Japanese dialog transcription assistance with the lines from *Drive My Car* and to Kyungwon Song for the Korean script of Kon Yoon-su's name.

2 There are several different ways to interpret Janice's translation. The word 逼 is pronounced like *b* in English, so it could be a straightforward onomatopoeic representation of beep. We know, however, that Janice is somewhat of a trickster, and she knows that many of the readers of this text are English speakers who do not speak Mandarin. The most diligent of these readers may consult Google Translate, which will tell them that

the full phrase 逼逼逼逼耶 translates as *fuck it*. While Taiwanese Mandarin speakers would find this surprising and more of an invention than an actual translation, Janice may have thought it was clever anyway. Alternatively, Janice may be referencing the *b* sound as a vulgar way of referring to a vagina, more like how the word pussy is used in English. Thus, when cursing, one might say "你媽的B/你媽的逼/你媽的屄," meaning "your mom's pussy" (please forgive us for being so impolite in this footnote). Finally, 逼 also means forcing someone to do something. For example, "她逼我去工作" translates to "She forces me to go to work." No one likes to be forced to go work. To express anger, one can add "她媽的逼":"her mom's pussy." We cannot be sure which meaning Janice is implying here; maybe it's all of them. We apologize for the ambiguity. Unless you like ambiguity, in which case, we hope that you are as delighted as we are.

Say Translation Is Art
by Sawako Nakayasu

Say this.

Say not this.

Say it again.

Like this.
Say it again say whatever it takes, whatever it
brings, say this.

Say translation as open art practice as open as
matter and anti-matter.

Say anti-translation as refusing, or not, to trans-
late altogether, say not this.

Say anti-translation as not refusing to translate,
just refusing to translate. Refusing to translate,
like this. Say it again.

Say I've never heard someone divulge so much
of their personal intimate life only to claim that

their politics are private, say coded language, say language is code.

Say translation of private space. Say public translation.

Say I share this shape with you, say your shape is your shape, like this.

Say nonbinary stance toward texts and translations. Say who, you.

Say who, I.
Say translating in the dark. Say smuggled translation, illegitimate translation, illegal translation, undefinitive translation, unauthorized translation. Screw and unscrew the hegemony cap translation.

Say feral translation.

Say eros in translation, say I want to be translated by you, say but not you, say I want, I want, I want, I say.

Say translation oceanic as desire.

Migrants' Routes, Ties, and Role in Empire, 1850s–1920s
by Lara Putnam

Thus sitting at the crossroads of the Caribbean, Jamaica supplied the great bulk of English-speaking black migrants to Central America and Cuba, and roughly half of those to the United States as well. Demographers estimated that Jamaica saw a net loss of 146,000 people to emigration in the last two decades of the nineteenth century and first two decades of the twentieth century. The total number of Jamaicans migrating was far greater, since seasonal and short-term migrants are not counted in net figures.[1]

Both Jamaica and Barbados had sent small numbers of migrants north to Boston and New York from the 1870s onward, creating significant enclaves in each city by the turn of the century.

Migration to the United States was accelerating as well. In the United States as a whole in 1920, there were 50,000 Afro-Caribbean immigrants, living alongside some 55,000 of their US-born children; a decade later, there were 72,000, with 83,000 US-born children.[2] By 1930

one-third of the black populations of Manhattan (fundamentally, Harlem), Brooklyn, and Boston and two-fifths of those of Cambridge and Miami were made up of foreignborn blacks and their children.[3]

Where did they hail from? By far the largest numbers came from Barbados and Jamaica, with Bajans slightly outnumbering Jamaicans in both New York and Boston.

Notes

1 George W. Roberts, *Population of Jamaica* (London: Cambridge University Press, 1957), 129. Gisela Eisner, *Jamaica, 1830–1930: A Study in Economic Growth* (Manchester: Manchester University Press, 1961), 150–51.
2 US Bureau of the Census, *Census of the United States*, 1930, vol. 2, 231, 33. These numbers exclude immigrants from Cuba and Puerto Rico but include other Spanish- and French-speaking islands.
3 US Bureau of the Census, *Census of the United States*, 1930, vol. 2, 33, 70–71, 250.

Ghost Prints of Loss
by Trina Michelle Robinson

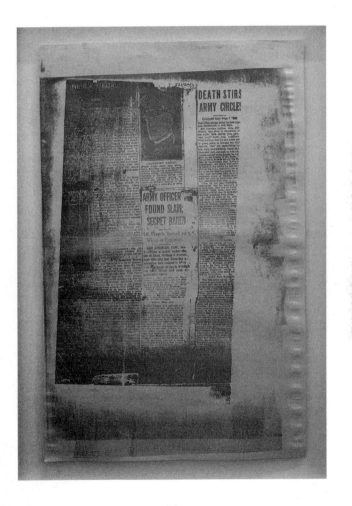

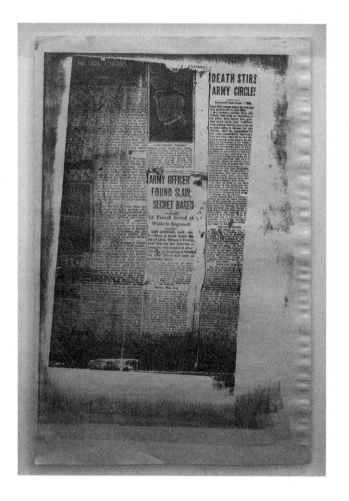

DEATH STIRS ARMY CIRCLES

ARMY OFFICER FOUND SLAIN; SECRET BARED

Lt. French Served as White in Regiment

Porous Records
by Bec Imrich

i. the way in

My maternal grandmother jumped off a bridge
when my mother was less than nine months old.

My mom was so young that she doesn't remem-
ber her mother or the details of what occurred,
just the aftermath and indirect accounts from
her eight siblings, each of whom recount a
markedly different version of the time surround-
ing the event.

She is a resilient and suspiciously optimistic
person, but I wonder what it would be like to
hear people speak in hushed tones or go silent
in your presence. Everybody always talking
around something. Right after it happened, she
and several of the youngest kids were separated,
sent off to stay with different family members
for several months—their mere existence too
much to grapple with. You could fill oceans with
what was left unsaid. Every once and a while,

my aunts compare stories of their impressions of that time, but their attempts at deciphering what happened to my grandmother are drops in a leaky bucket.

When I was young and we visited family in Washington, DC, every time we crossed a bridge it would be brought up matter-of-factly. "My mother jumped off a bridge," she would say, without elaboration. My sister and I eventually worked up the courage to ask questions, but the details remained foggy. She seemed muddled about where specifically it had occurred—or maybe I was. I would hold my breath every time we crossed any bridge, unsure if it was *the* bridge.

Eventually, the name "Calvert Street Bridge" surfaced.[1] I'd crossed it unknowingly before, in a car. Looking at aerial pictures, I was surprised to see how small and shallow Rock Creek looked underneath. A small brook, but mostly just hard ground next to an asphalt parkway. Nothing much soft to land on.

I was overcome by emotion the first time I saw Sarah Charlesworth's series *Stills*. The artist collected newspaper images of people jumping

out of buildings, removed contextualizing infor-
mation from the backgrounds, and enlarged the
photographs into life-sized mural prints.[2] This
felt like the closest I had gotten and would ever
get to seeing or fathoming what had happened
to my grandmother. In *Stills*, the impetus for
each person's plummet are beyond the bounds of
comprehension, but the ambiguity generated by
the photographs' material graininess leaves room
for an affective collision across space and time.[3]
Charlesworth's series called up abject emotions
and intrusive projections of memories that had
been inaccessible to me, giving form to a buried
family event that couldn't possibly be visualized.[4]
It's startling that these images of complete
strangers filled a void in my understanding
of my own family's history. This experience
also affirmed my belief that when we prod our
expectations about photography as documentary,
stimulating questions unfold.[5] Photographs
are in many ways fictions masquerading as
reflections, but they can provide an entry point
to understanding emotional landscapes that are
otherwise just out of reach.

I've searched microfiches and online databases
with her name, the year range, and macabre
keywords. Looking for some nonexistent

"objective" accounting of the unfathomable. My amateur detective work has been further thwarted by the fact that my grandmother married someone with the last name Smith. I have never found anything in public records that referenced her death directly, but I did find articles about the number of fatal jumps on that bridge in any given year—and, much later, about the tall wrought iron fence erected there for the purpose of suicide prevention.

So I'm left to revisit family albums that include newspaper clippings and youthful retouched studio photographs in which she looks beautiful but indistinguishable from portraits of others taken in that era (although there is plenty to unpack in terms of signifiers for a highly educated, affluent, white demographic).[6] I know more photos of her exist, but only a precious few of them depict her as a mother, or in the years close to her death. The ones preserved in albums are mostly of her childhood or wedding photographs. I'm left scrounging for nuance between the airbrushed version of the truth and the pernicious darkness that gets glossed over.[7] No one's death should define them. Still, the omissions function like a black hole; all the energy is drawn toward what is left out.[8]

There is one particularly haunting portrait of my mother's family taken outside my great great grandparents' house in central New York.[9] I'm generally averse to staged family portraits, both as a reluctant photographic subject myself and as a snide observer of overproduced holiday cards. But you can tell a lot about hierarchies and entangled relationships by considering how people want to be seen, even if you know that their projections are far from reality.[10] New details emerge each time I look at the image. My grandfather had polio as a child, and when he was photographed he would stand with his smaller right arm wedged into his pocket. My reading of the image changes depending on my own state of mind and who is there with me, coaxing my eyes in one direction or another.

The picture has always disturbed and unsettled me. Discomfort with the formality, the pairs of matching outfits on the children, and the attempts to arrange family members and couples symmetrically in a way that reads legibly as a prosperous heteronormative family. Almost everyone in the picture is squinting into the sun, and my forehead crumples, mirroring their unease when I look at the vaguely pained expressions on their faces. Not to mention the

implications of staging such a portrait so soon after my grandmother's death. Her absence is palpable, even though there is no physical space next to my grandfather in the photograph.[11] Is the portrait a veiled attempt at projecting stability into the world even though, below the surface, things are far from it?

This is my way in. The fissures in my family's narrative have made me hyperaware of the stakes of family photographs, positions subconsciously taken, and the myths being woven when a family album is assembled. Vernacular photos are fragments of larger stories, evidence of the weight of grander forces, and products of the "reality engines" that prop up patriarchy, whiteness, and capitalism.[12] Family albums should be examined as seriously as any other history book.

ii. pasting fragments together[13]

This isn't just about unreliable narrators; it's about how personal stories serve as building blocks in the fabrication of larger mythologies. Close, sustained looking starts to make apparent the contrast between what you see, feel, and were told. And if we consider the album as a

tangible proxy for and fragment of larger constructed narratives, then there is potential in its rearrangement. If we can't unpack the constituent parts, how can we fathom addressing bigger questions surrounding the dismantling of class, gender, and racial hierarchies?

If photographs "condition our ways of seeing" (for better and worse), how can we untangle, reframe, and trouble this habituation?[14]

Three artists with varied practices offer pathways to unpacking and reenvisioning our own archives. Lorraine O'Grady, Leslie Hewitt, and Buck Ellison have used fictionalized fragments of family photo albums to unearth alternative ways of knowing the past to reframe the present. Their projects ask: What truths can be mined from fictions?[15]

O'Grady's *Miscegenated Family Album* (1980/1994) is an object lesson in the generative dialog that happens when you view history through a personal lens and vice versa, poking holes in engrained narratives in both. The project urges a consideration of the family album as an important site for contested histories on both a micro and macro scale: how personal relationships and family

lore are ensnarled with larger historical forces and problems.[16] The series is presented not in book form but as a series of diptychs, in which archival images of Egyptian artifacts depicting Nefertiti and her family are juxtaposed with photographs from O'Grady's own family.[17] The images have been cropped to highlight striking visual echoes, but in association they do more than posit a simple equation of this = that. Photo historian Laura Wexler builds on Frederick Douglass's speeches to develop the concept of the revenant in photography, the capacity of images to resurrect their subjects from social death.[18] Such revenants are alive in *Miscegenated Family Album*. O'Grady brings mythologized historical figures and family members back from the dead while calling the Eurocentric presentation of historical narratives of ancient Egypt and the dynamics of her own Black middle-class family into question.[19] She uses the dyadic format to set up a "ceaseless conversation" that refuses tidy resolution.[20]

In *Riffs on Real Time* (2006–09), Leslie Hewitt also uses fragments of family albums and vernacular photos to orchestrate a kind of archival improvisation. Hewitt takes care to note the significance of the quotidian and overlooked,

linking personal photographs with more recognizable touchpoints in history by drawing on our tendency to construct relationships between images that are coexisting in the same frame. She arranges ephemera (often including photos from family albums other than her own), forging connections between found images, texts, and textures.[21] Equal significance is accorded to a picture of a Black middle-class family at a barbeque in the 1970s, for instance, to images of demonstrations against apartheid by Soweto students, published in *Ebony* magazine in 1976. The items are often arranged on a surface within the homes in which they were found, whether it be a colorful high-pile carpet or a wood floor with scuff marks. Hewitt's work recalls the haptic experience of sifting through archives and allows embodied traces and memories from Black Americans to accumulate into a collective dialog that is unfixed, evolving across iterations.[22] One bit of ephemera occludes another, but their physical and conceptual layering also generates alternative interpretations, collapsing public and private spaces to forge the link between personal and political.

Buck Ellison's work also invites thinking about the family album as integral to constructing

and deconstructing entrenched (yet often unspoken) ideas about race and class. Ellison's research-based photographs are staged, cast and painstakingly styled to fall somewhere between reenactment and advertisement. His subtly disquieting images of elite white families reference an aggregation of family-portrait tropes and signifiers of wealth, some of which are mined from his own surroundings growing up in Marin, California and attending Columbia University. The subjects are largely paid actors—and this doubling renders the artifice of the images legible. Ellison's uncanny stand-ins reveal this genre of portraits for what it is: an idealized facade built with clothing, furnishings, and poses.[23] If we acknowledge that photography has always been used as a tool that "framed the colonialist project, visually buttressing the wider logic of European colonial rule," then how are these logics perpetuated in our contemporary context?[24] By closely reading the symbols that play a part in constituting whiteness and re-presenting them to us in a way that foregrounds their strangeness, Ellison's work points toward a more existential examination of whiteness as a construction whose logics have real and dire consequences.

iii. the way through

Historical narratives often seem immutable, but they are porous. Just as images can be added, omitted, or rearranged in a family photo album, larger histories should be continually reconsidered. O'Grady, Hewitt, and Ellison affirm that small permutations in archives can have a butterfly effect outward. These part-archival, part-fantastical projects redistribute the weight accorded to different source material and subtly expose artifice and missing pieces in long-established records. They make invisible belief structures visible by paying attention to how neglected aspects of quotidian memory are linked to bigger systems of power.

In its form, family albums can function as a series of diptychs that pose more questions than they answer.[25] We can envision such artifacts as akin to ancient wax tablets.[26] Each time the volume is opened, images can be "read" anew.[27] Narratives are rewritten and reframed, but the palimpsest of what was there before remains, offering possibilities for the future through exchanges with the past.

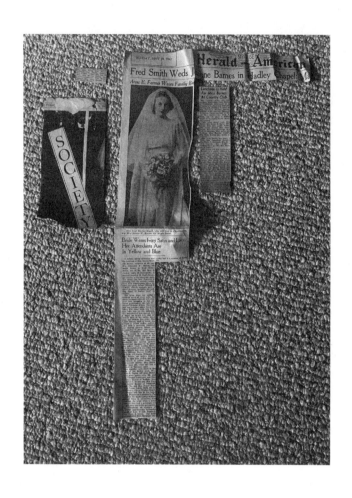

fig 1. One of the few pictures of my grand-
mother taken from an insert in a family album.

fig 2. Sarah Charlesworth, *Unidentified Woman,
Hotel Corona de Aragon, Madrid*. The Art
Institute of Chicago, promised gift of Liz and
Eric Lefkovsky. Silver gelatin photograph from
the series *Stills*, 1980, printed in 2012 as a
unique set of artist's proofs, each 78 × 42 inches.

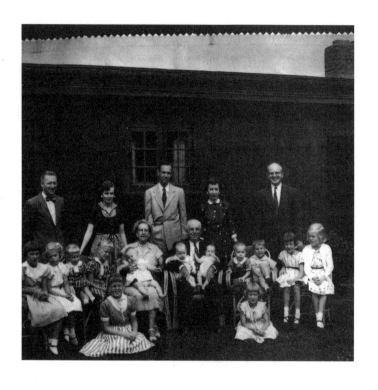

fig 3. Portrait of my mother's family (my grand-
father is in the center of the top row in tan suit,
and my mother is the baby asleep in the middle
row amongst her siblings and cousins, being
held by my great-great-grandmother).

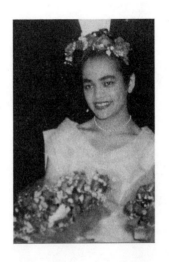 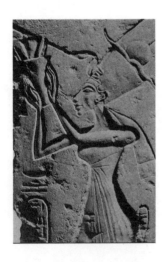

fig 4. Lorraine O'Grady, *Ceremonial Occasions I (L: Devonia as Matron of Honor, R: Nefertiti performing a lustration)*, diptych from the series *Miscegenated Family Album*, 1980/1994. Silver dye bleach print, 26 ½ × 37 ½ in. (67.3 × 95.3 cm). Art Institute of Chicago, Through prior bequest of Marguerita S. Ritman; © 2022 Lorraine O'Grady / Artists Rights Society (ARS), New York.

fig 5. Leslie Hewitt, *Riffs on Real Time* (7 of 10), 2006–2009. Chromogenic print, 30 × 24 in. (76.2 × 61 cm). Solomon R. Guggenheim Museum, New York, Purchased with funds contributed by the Photography Committee, 2010; © Leslie Hewitt.

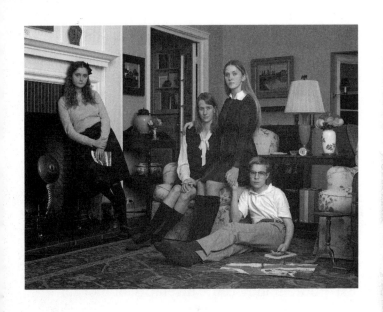

fig 5. Buck Ellison, *The Prince Children, Holland, Michigan*, 1975, from the series *Living Trust*, 2019. Archival pigment print, 60 ¼ × 79 ½ in. (153 × 202 cm). Courtesy of the artist, Balice Hertling, Paris, and The Sunday Painter, London.

Notes

1 My grandmother passed in 1953. The bridge was renamed Duke Ellington Bridge in 1974. In the 1980s a suicide prevention railing was added.

2 I saw this series in 2017 in the retrospective *Sarah Charlesworth: Doubleworld* at the Los Angeles County Museum of Art (August 20, 2017–February 4, 2018).

3 Leslie Dick, "Intentional Accidents: Reflections on Sarah Charlesworth's Stills," *X-TRA* 18, no. 3 (Spring 2016), https://www.x-traonline.org/article/intentional-accidents-reflections-on-sarah-charlesworths-stills.

4 As Susan Sontag posits in *On Photography*: "Photography is the inventory of mortality [...]. Photographs state the innocence, the vulnerability of lives heading toward their own destruction, and this link between photography and death haunts all photographs of people" (New York, NY: Farrar, Straus, and Giroux, 1973; New York: RosettaBooks, 2020), 54–55, e-book.

5 Charlesworth, in this case, is literally cropping, reprinting, and reframing other photographers' documentary images, but by

removing their context, she leaves us in a state of suspension. In "Intentional Accidents," Dick writes about how some images from this series document suicides, while others are stunts, but when they are presented in this context, we can't tell the difference in motivation.

6 In *Image Matters: Archive, Photography, and the African Diaspora in Europe*, Tina M. Campt states that "sometimes it is the ordinariness of photographs (their unexceptionalness) [that] gives them power" (Durham, NC: Duke University Press, 2012), 14.

7 "'[M]yself' never coincides with my image; for it is the image which is heavy, motionless, stubborn (which is why society sustains it), and 'myself' which is light, divided, dispersed […]." (Roland Barthes, *Camera Lucida*, Macmillan, 1981), 12.

8 We are socialized to believe that depression is a personal or familial problem to be dealt with privately, but the unsaid ripples outward. In her 2020 essay "Sick Woman Theory," Johanna Hedva cites and builds upon Ann Cvetkovich's book *Depression: A Public Feeling* (Durham, NC: Duke University Press, 2012). Cvetkovich writes: "What if depression, in the Americas, at least, could be traced to

histories of colonialism, genocide, slavery, legal exclusion, and everyday segregation and isolation that haunt all of our lives, rather than to biochemical imbalances?" She continues: "Most medical literature tends to presume a white and middle-class subject for whom feeling bad is frequently a mystery because it doesn't fit a life in which privilege and comfort make things seem fine on the surface" (3). See also: https://johannahedva .com/SickWomanTheory_Hedva_2020.pdf.

9 In "The Family Photograph Album: So Great a Cloud of Witnesses," Philip Stokes speaks about the recurring motif in family portraits of people standing outside their homes as a way to connect people to their material possessions (in *The Portrait in Photography*, ed. Graham Clarke [London: Reaktion Books, 1992], 196). In her essay "Whiteness as Property," Cheryl I. Harris elaborates on this connection: "Following the period of slavery and conquest, whiteness became the basis of racialized privilege—a type of status in which white racial identity provided the basis for allocating societal benefits both private and public in character. These arrangements were ratified and legitimated in law as a type of status property. Even as legal segregation was

overturned, whiteness as property continued to serve as a barrier to effective change as the system of racial classification operated to protect entrenched power" (*Harvard Law Review* 106, no. 8 [June 1993]: 1709, https://harvardlawreview.org/1993/06/whiteness-as-property/).

10 "[T]o look at the portrait of an individual is to invite oneself to all sorts of speculations as to who they were… to look at a family group is to add the assumption of a whole thicket of connections between the sitters[…]." (Stokes, 192). There are several contemporary theorists whose work on the subject of the significance of the historical traces left by vernacular photographs is pivotal: Deb Willis, Laura Wexler, Tina M. Campt, and many others. Wexler and Campt posit that photographs don't just reflect how things were but rather document decisions and "intentions" (Campt, *Image Matters*, 6). Maurice O. Wallace and Shawn Michelle Smith note that photographs don't just portray the world but function to "condition a way of seeing" (Wallace and Smith, eds., *Pictures and Progress: Early Photography and the Making of African American Identity* [Durham, NC: Duke University Press, 2012], 3).

11 Absence as presence is a recurring theme in photo theory. I'm interested in how the (clearly orchestrated) symmetry of the adults in the top row of the image, with my grandfather in the middle of his siblings and their spouses, initially distracts your eye from who is missing (my grandmother).

12 In his book *The Image of Whiteness: Contemporary Photography and Racialization* (London: SPBH Editions, 2019), Daniel C. Blight writes about how "whiteness becomes one cog in a larger 'reality engine,' one built to suit white worldviews committed to the supremacy of whiteness and the dehumanizing of Black and Brown people. If you are socialized white, if your 'reality engine' is geared towards whiteness, your unconscious mind determines the extent to which you 'see white'" (23).

13 Lorraine O'Grady has said, "I think everyone has parts of themselves that they can't quite fit together—so you have to fit the pieces together to make yourself a whole person. You're either doing it consciously or subconsciously but you're pasting yourself together[…]. None of us are speaking for everyone, only speaking for our own portion of reality" (https://www.youtube.com

/watch?v=60U8FXYS69A&ab_channel=Tate).

14 Wallace and Smith, eds., *Pictures and Progress*, 3.

15 This line of questioning owes credit to a conversation I had with artist Sam Vernon in the Wattis Institute's Lorraine O'Grady Reading Group.

16 Aruna D'Souza, "Lorraine O'Grady: Self and History" (Zoom presentation, hosted by Mahindra Center for the Humanities, Harvard University, Cambridge, MA, February 11, 2021).

17 As both O'Grady and D'Souza have delineated, O'Grady was ahead of her time in challenging the canon of ancient Egyptian history, which was previously framed through a European/Eurocentric lens (and still is in many ways).

18 Wallace and Smith, eds., *Pictures and Progress*, 10; Laura Wexler, "'A More Perfect Likeness': Frederick Douglass and the Image of the Nation," in *Pictures and Progress*, 18–40.

19 Institutional theft of Egyptian antiquities (by the British Museum, for example) often results in control over how these objects (and the historical figures that they depict) are framed. A family album can function similarly, but people rarely think about them that way

(Who took the photos? Who sequenced them? Who is the arbiter of the family history?). In her work O'Grady presents a critique of the institutions of museum and family at the same time.

20 Lorraine O'Grady, "Notes on the Diptych," in *Writing in Space*, 1973–2019, ed. Aruna D'Souza (Durham, NC: Duke University Press, 2020), 140.

21 Jennifer Blessing, *Photo-Poetics: An Anthology* (New York, NY: Guggenheim Museum, 2015), 68.

22 In their respective works, Campt and Allan Sekula both speak about the haptic qualities of looking through photographs. See Campt, *Image Matters*, and Sekula, "The Body and the Archive," *October* 39 (Winter 1986): 3–64, https://doi.org/10.2307/778312.

23 In "The Borders of Whiteness: Interview with Yasmin Gunaratnam," Gunaratnam speaks about "colonial amnesia" and the "denial of whiteness as a racial structure" (in Blight, *The Image of Whiteness*, 165–66).

24 Blight, *The Image of Whiteness*, 21.

25 "The goal of her diptychs is not to bring about a mythic 'reconciliation of opposites,' but rather to enable or even force a conversation between dissimilars long enough to

induce familiarity. For O'Grady, the diptych helps to image the kind of 'both/and' or 'miscegenated' thinking that may be needed to counter and destabilize the West's either/or binary of 'winners or losers,' one that is continuously birthing supremacies, from the intimate to the political, of which white supremacy may be only the most all-inclusive" (https://lorraineogrady.com/wp-content/uploads/2019/03/190312_OGrady_BRIEF-BIO_FINAL.pdf). See also: O'Grady "Notes on the Diptych."

26 The earliest known diptychs were writing tablets (usually made out of wood, bone, or metal) which were coated with a layer of wax that could be inscribed on and then melted away. See: https://blogs.bl.uk/digitisedmanuscripts/2019/05/keep-taking-the-wax-tablets.html.

27 "The process of structuring and restructuring the family album reveals how the status of photographs ebbs and flows between that of precious object and an autumn leaf ephemerality. What one generation builds, another reconstructs and a third may discard, only to earn the perpetual resentment of a fourth generation, who scrabble archeologically to find what may be amongst the remnants'" (Stokes, *The Family Photograph Album*, 204).

Untitled (Aug 1, 2017)
by E. Jane

Sometimes I get so angry about the lack of representation of darker skinned Black women descendants from slaves in media that I just want to run away.

Whenever we are on TV we always have "proper" accents unless we're comedic effect, in many shows we are embarrassed we come from Blackness if we're successful in whiteness or Blackness is conflated with working-classness and we feel shame for both OR we are sexy and sassy and hard to win for a white man. I am generalizing, but if you look at any big network and you see Black women descendants of slaves who are darker skinned (a mouthful of specificity) on the screen, this is how they normally are portrayed.

Thinking especially about "How To Get Away With Murder" (best episode is when Anna Mae goes down south) like when Michaela switched out of her Black valley girl accent at dinner with her almost-soon-to-be stepmom and told her to back up and I wondered why a lawyer can't sound like she's from the south all the time, "Black-ish"

like when Rainbow's mom admits her name isn't proper and chocks up changing it and her lifestyle to survival, and I don't watch "Scandal" anymore BUT that show would be more "progressive" if Olivia didn't have to have an affair with a white man to be powerful. I'm frustrated because I love media and especially TV and it never seems to love me back. Where is the modern day Moesha?

Because I've grown up with few characters on TV that look like me, but also feel raised predominantly by TV and the internet, I used to think there was something wrong with me, that I had been born wrong or switched at birth with some other child who looked more like the child of the late 80s/early 90s ideal Dark skinned Black man and non-Black woman parenting combo. My parents seemed represented in media, and the children they were supposed to have, but I did not, have never except for when Moesha existed, except for when I got to see Whitney Houston on TV (And she was still very slim and "ideal").

Writing this all on fb fixes nothing. Still, I checked my feed this morning and these are all the vulnerable feelings that rushed out.

More joyful thought: I wonder what TV will look like in the future once capitalism is dismantled.

August 1, 2017

Glitch Refuses
by Legacy Russell

Feminism is an institution in its own right. At its root is a legacy of excluding Black women from its foundational moment, a movement that largely made itself exclusive to middle-class white women. At the root of early feminism and feminist advocacy, racial supremacy served white women as much as their male counterparts, with reformist feminism—that is, feminism that operated within the established social order rather than resisting it—appealing as a form of class mobility. This underscores the reality that "woman" as a gendered assignment that indicates, if nothing else, a right to humanity, has not always been extended to people of color. Feminist "sisterhood" toward the purpose of increasing white range and amplified social, cultural, economic mobility, is an exercise in service of supremacy—*for white women only*. This is the ugly side of the movement: one where we acknowledge that while feminism is a challenge to power, not everyone has always been on the same page about who that power is for and how

it should be used as a means of progress. *Progress for whom?*

[...]

As we wade our way through contemporary feminisms and the negotiations of power embodied by #BlackLivesMatter, #MeToo, or the tradition of the Women's March, we must recognize that these movements are defined and driven by technology, harbingers of a promising and potentially more inclusive "fourth wave" unfolding on the horizon. Still, the dangerous vestiges of first- and second-wave histories linger on. Writer, activist, and feminist bell hooks may have declared that "feminism is for everybody," but what remains is still a long and winding road ahead until we get there.

Where *glitch* meets *feminism* in a discourse that problematizes the construct of the body, it is important to call out the historical construction of gender as it intersects with a historical construction of race. The body is a social and cultural tool. Because of this, the right to define what a body is, in addition to who can control these things called "bodies," has never been meted out equally. In a contemporary landscape where the term "intersectional" is bandied about

with such ease, it is important to acknowledge the work of blackness in particular toward the project of feminism.

[...]

We cannot forget: it was, and continues to be, the presence of blackness that aided in establishing a primary precedent for the notion of intersectionality within feminism. *Intersectionality* as a term was coined in 1989 by theorist and activist Kimberlé Crenshaw to speak to the realities of blackness and womanhood as part of a lived experience, neither half exclusive of one another, but rather advancing the work of both sides. Crenshaw's enduring contribution bolsters the foundation for the early thinking that drove making space for multiplicity across selves within a broader social and cultural context, one that resonates today both online and AFK alike.

As German artist and cyberfeminist Cornelia Sollfrank observes: "Cyberfeminism does not express itself in single, individual approaches but in the differences and spaces in-between." It is in the space between that we as glitch feminists have found our range, our multiple and varied selves. Thus, the work of blackness in expanding feminism—and, by extension, cyberfeminism—

remains an essential precursor for glitch politics, creating new space and redefining the face of a movement, amplifying the visibility of historically othered bodies.

We can find examples of this in texts such as writer Octavia Butler's 1980s *Xenogenesis* trilogy, which galvanizes the notion of a third sex futurity that defies binary gender. Or Audre Lorde's discussion of the erotic as power in her 1978 paper "Uses of the Erotic: The Erotic as Power," which encourages us to discover our full range through a self-connection that delivers joy. These contributions did not rise up out of cyberfeminism, but they have transformed, expanded, and liberated it. Such alchemy makes limitless the capacity of glitch to mobilize.

Let us revisit, occupy, and decolonize Whitman's words in our call for refusal:

Do I contradict myself?
Very well then I contradict myself,
(I am large, I contain multitudes.)

10

Remnants, Portals, and Power:
The Space I Am In
by Alisha B Wormsley

when existence is [in]formed by death one must conjure out of form to survive.

this is the craft of spirituality inspired by the SIBYLS (then and now and soon).

this work is a dialogue between black woman and environment.

the specifics of the environment are insignificant. informed by collapse and time.

to survive, one must know space.

I dream about black women.

how we are constantly informed by our nature. this nature encourages an understanding out of form. this form comes from the void to help us remember.

so. what is "erasure" and what is a "conjuring" -- and how might those lines overlap?

how attached can we be in these interspaces?

even the space of body.

there is repetition, returning again and again to a place to (re)build.

what conjuring is used?

these are the ORACLES.

so says beautiful spirit

Laure of *Olympia*: A Revision of Precedent
by Denise Murrell

In early 1863, Manet resumed his work with
the model Laure, now together with Victorine
Meurent, for the making of a major work in
which he transforms their images from the
mode of portraiture to that of performance.
In the painting later known as *Olympia*, each
model posed a role emblematic of modern
life—Victorine as the unsentimental prostitute
who was rapidly replacing the deferential,
Renaissance-style courtesan, and Laure
as a representation of the changing racial
composition of the Parisian working class.

While *La négresse (Portrait of Laure)* was
an empathetic depiction of Laure, Manet
positioned her as Olympia's maid with seeming
ambivalence. Here, Laure is again clad in attire
reflecting hybrid French and Antillaise influenc-
es. Yet the overall effect, on first impression, is
very different. In *Olympia*, Laure has a central
place within the pictorial plane, well positioned
to be a focal point. But other details conspire
to exactly the opposite effect, and the figure's

modernizing features are all but obliterated for many viewers. Still, with sustained attention, the figure of Laure in *Olympia* reveals a metonymy, a duality of overt tradition and sublimated innovation.[1] The figure evokes stock types, yet begins to evolve from then-prevalent modes of stereotyping, while being wholly consistent with the formal devices of modernist painting.

T. J. Clark stated that a defining characteristic of modernity in 1860s Paris was the breakdown of long established bourgeois behavioral norms, including a shift of recreational activities from private to public venues and a more overt presence of prostitution within society.[2] Manet's representation of the prostitute in *Olympia* has long been understood to be the crux of this discontinuity. Clark provides a comprehensive iconographic lineage for *Olympia* and documents the extensive critical and artistic commentary about this figure, which he concludes was "the main representation of modernity in 1860s Paris"; but he asserts that the maid, while "modern," ultimately meant "nothing."[3]

Yet a close formal analysis of the painting, as well as a broader examination of the multiple contexts within which *Olympia* was created, titled, and displayed, suggests that Manet's revisionary depiction presented the black maid

as a second focal point and site of disruptive modernity. This doubled lack of fixity, or disruption of pictorial convention, was crucial to the modernity of Manet's *Olympia* and to the silence and negative initial response it provoked upon its first showing at the 1865 Salon. Manet thus maintains, even intensifies, the de-Orientalized cultural hybridity of Laure's depiction initiated in *La négresse*. Manet's continuing commitment to observed truths noted during his routine encounters with women of color, whether as passersby in the park or through social and artistic contacts (Jeanne Duval), can be seen as an early modern artistic representation of the emerging cultural hybridity, defined by Maryse Condé a century and a half later, of the free black community then staking out a place in the same northern Paris neighborhood where Manet lived and worked.[4]

The modernizing rupture that Manet's painting ushers in is evident in even a superficial comparison with Titian's 1538 *Venus of Urbino*, a Venetian Renaissance painting invariably cited as the source for *Olympia*.[5] Manet flattens the spatial depth, refusing the Renaissance perspective of Titian's work as he forecloses the view into the room with a heavily draped curtain and shadowy tonalities. The scene presented to us is

that of two figures thrust into the foreground of a shallow two-dimensional space, rather than of a window through which we are drawn into an illusion of interior space. This closing off of a view into depth would normally deflect attention from content to surface as the materiality of the support competes for visual interest.

Manet simultaneously invites viewer interest in *Olympia* through radical revisions of expected figure tropes. The depiction of the prostitute transforms one standard by converting Titian's invitingly diffident courtesan into a confron-tational sex-for-pay worker. *Olympia* meets our gaze with an assertive stare in place of the demure glance of Venus; her gray-white flesh and thin, flattened physiognomy replace the naturalistic tones and voluptuous curves of her Renaissance precedent. Manet's depiction of the prostitute laid bare the modern reality that pros-titution as a sex-for-cash commodity enterprise was supplanting the tradition of the cosseted and discreet courtesan who, with a luxurious lifestyle maintained by wealthy patrons, existed outside the money economy. It was therefore a key factor disrupting the fixity of the social classes in modern Parisian life.

The maid is likewise presented in a revisionary manner. While Titian's maid is

proportionally much smaller than the courtesan, Manet's maid assumes a spatial dimension nearly equivalent to that of the prostitute. And though positioned behind and subordinate to the prostitute, Manet's maid faces us from the foreground of the picture, in contrast to her counterpart, who turns away far in the background depth. The greater equivalence between the two figures in *Olympia* sets up a counterbalancing relationship between them in purely formal terms—the maid's blackness is heightened by the prostitute's whiteness, and vice versa—with the effect, for many critics, of transferring a racially charged connotation of uncleanliness and illicit sexuality from the black maid to the white prostitute. Beginning with Manet's friend Émile Zola's review of *Olympia* at the Salon, this is the primary context in which the maid has been historicized, if mentioned at all.[6] Still, the maid's frontal placement may also suggest that Manet intended her to be an object of attention in her own right.

Notes

1 Jennifer DeVere Brody, "Black Cat Fever:
 Manifestations of Manet's *Olympia*," *Theatre
 Journal* 53, no. 1 (2001): 97.

2 T. J. Clark, "Olympia's Choice," in *The
 Painting of Modern Life*, rev. ed. (Princeton,
 NJ: Princeton University Press, 1984),
 105–7.

3 T. J. Clark, "Olympia's Choice," 69, 93, 146.

4 *Penser la créolité*, ed. Maryse Condé and
 Madeleine Cottentot-Hage (Paris: Karthala,
 1995), 305–10; Holly Collins, "La querel/e
 de la créolisation: Creolization vs. créolité
 in Glissant, Condé, and the Creolists,"
 Nottingham French Studies 56, no. 1 (February
 2017): 67–71.

5 Clark, "Olympia's Choice," 93; Juliet
 Wilson-Bareau, "The Hidden Face of Manet:
 An Investigation of the Artist's Working
 Processes," *Burlington Magazine* 128, no. 997
 (April 1986): 44.

6 See Stéphane Guégan et al., *Manet: The Man
 Who Invented Modernity*, exh. cat. (Paris:
 Musée d'Orsay, 2011), 136–37, for an expo-
 sition, exceptionally in some length, of Zola's
 formalism, and a rejection of its failure to
 take content into account.

Under Construction
by Camille Chedda

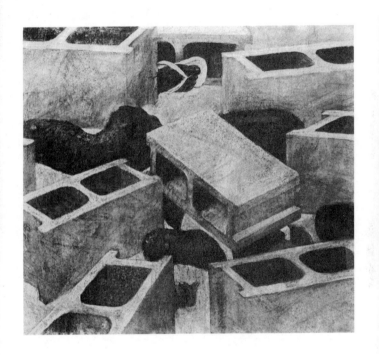

Swallow the Fish
by Gabrielle Civil

I had never thought of myself as a fearful person, but performance art made me confront my fears. And also my desires. At the start, not the question: what would a performance artist do? Because the answer was everything, anything. At the start, this question: who got to do those things? Who got to be a performance artist? Which people in which bodies?

I remember seeing Karen Finley in New York City. She hadn't swallowed any live animals (although it wouldn't necessarily be beyond her), but she had stripped down to just panties and put her feet in a basin of water which (as anyone who has ever stepped naked in water knows) gives you the overwhelming desire to pee. Karen Finley calmly told us that was what had happened to her, grabbed a bucket, and peed right there into it on stage. It was shocking, but also liberating. It was the brazen nastiness of white girls that had always been intimated to me in my youth. (*White girls, you know how they are … They'll do anything. Pee in the woods, walk around*

butt naked in the showers. They're loose, they're easy, they're crazy.) As a black girl, as a strong black woman, I was supposed to be appalled and superior to that kind of behavior. But at times, I was covetous. How come *they* got to do that? Where did they get that allowance? I had never seen a black woman do such things and wondered if they were even possible.

Years ago, I had an artist show-and-tell at my house. I'd started moving from poetry into performance and had just gotten a big grant to turn my experience translating a long Haitian poem into a new performance art piece. When Colin suggested swallowing the fish, something rippled in me. I wanted Miré to swallow the fish. I wanted her, a black woman, to stare down craziness, to allow herself to be crazy, to do something crazy on stage. Hell, I wanted to swallow the fish myself. To be as loose and crazy and unstoppable as those white lady performance artists like Karen Finley and Holly Hughes and Marina Abramović. I wondered if I could do it.

"If it's necessary for the piece, then she needs to do it," Colin had said. The realization of need. Going deeper, taking it all a step further. I thought of the time I showed my landlords, my two great, gay godfathers whom I adore, some segments from *Divine Horsemen*, Maya Deren's

documentary on Haitian *vaudoun*. One moment
in the dance, the *houngan*, the priest, slits the
throat of a chicken. You see its blood pour down
to the earth below. That death is a necessary
ritual that connects the worshippers to the spirit
world beyond. My landlords were outraged at
the violence, but I felt honored, stirred. We were
witness to the transfer of one life to another, one
energy to another—not for entertainment or
shock value but for transformation.

 Swallowing the fish would have
 to be like that.

 Making performance art as well.

 To swallow the fish, you had to have some-
thing more than a reason. In a way, you had to
reject reason itself. You had to have spirit (and
perhaps spirits and the spirits too). Especially as
a nice black girl, as a strong black woman. You
couldn't just get away with whatever. Hell no.
You could be crucified for that, or worse, gain a
bad reputation. Animal murderer. Race traitor.
Nasty girl. Acting crazy. Acting up. Performing.
Anything could happen to you. Anything could
happen. It couldn't be pretense or something
to do for kicks. It had to be real. There had to
be some black art, some power, some need and
conviction that warranted that kind of transfor-
mation. A particular kind of magic ...

In the end, Miré chose not to swallow the fish or even to use a goldfish in a bowl at all. She passed a bucket with a freshly caught trout through the audience, a hook still dangling from its lip. She told a story in the accent of a fisherman displaced from his home, tying hooks into knots in a net. Then she masqueraded as a corporate raider with a clipboard, planning a new corporate development on the site. She only did the piece twice, one weekend at Patrick's Cabaret in Minneapolis, and hasn't revived it since.

In the meantime, that goldfish (*rippling wound or wound*), the challenge to swallow it, became mine. It belongs to anyone moving toward the form of performance art, struggling to figure out what it means, what is required to do it, what kind of body and spirit you would need.

From Me to Them to Me Again:
Text in Three Parts to Accompany a Diptych Portfolio
by Lorraine O'Grady

Introduction (2019)

In 2017, I felt a desperate need to reconnect to the voice I'd had before entering the art world, so it could help with a new body of work I expected to be more personal. In 1977, after attending the Iowa Writers' Workshop for fiction, after being a literary translator and a rock critic, and after teaching humanities at the School of Visual Arts in New York, I'd had a crisis of the female body: a breast biopsy that proved negative. I was so relieved, I made a newspaper poem from the Sunday *New York Times* as a thank you present for my doctor and was surprised how good it felt, how good the poem was. I kept going and made one each Sunday, cutting out every section but the employment and real estate ads for six months. I was a writer when I began *Cutting Out the New York Times (CONYT)* in June 1977. When I finished in November of that

year, I knew that I'd also become a visual artist.

But entering the art world three years later disoriented me. It was the most segregated world I'd yet been in, with an irrationality too defended to counter. After devoting so much time to explaining "it" to me, confronted with an intransigent art world, now I was explaining "it" to them. In 2017, forty years later, I returned to the 1977 series in order to connect to the sound of my old voice. But before the earlier piece could realign me with who I had been, I would have to bring it closer to who I was now. I created a new series from it using what I had learned since. Though *CONYT* may have succeeded in its goal of making public language private, the new radically selected and rearranged "haiku diptychs" of *Cutting Out CONYT* (1977/2017) would be the counter-confessional poetry *CONYT* had only dreamed of. Once finished, I basked briefly in a job well done. And then it was 2018.

No one could take away my accomplishment with the new series, but like minority artists everywhere, I would have to do *more*. It's not enough to make the work. First, one may have to answer questions of motivation: Why this? Why now? What are you *doing*? More often, one must find or invent language so the work can be

understood, be *seen*, by us as well as them. This can frequently take years. I love the quote by Toni Morrison: "The function, the very serious function of racism … is distraction. It keeps you from doing your work. It keeps you explaining over and over again."[1] It can also make you forget that that's what you've been doing. When I look back at the two statements that follow, made twenty years apart, I must ask: To what extent have I been repeating myself? Did I get somewhere? Can my images at last speak for me? Where must I go? What must I do with what I see here?

exhibit A (1998)
the diptych vs. the triptych

Excerpt from an unpublished conversation between Lorraine O'Grady and a studio visitor, September 12, 1998

VISITOR: You've said your work is an argument against Western dualism. But if that's the case, why do you use two panels? Doesn't that just reinforce the basic idea? Why not the triptych instead?

LORRAINE O'GRADY: I know it seems odd, but this is one case where reality does not support common sense. You'd think that dualism would be reproduced in two panels, but it can't be. Two does not equal two here, no matter how it might appear at first. It took me a while to figure out that, in Western dualism, there's a kicker, and it's hierarchy.

VISITOR: Which means?

O'GRADY: Since Western dualism is hierarchical, there can't be balance or equation: good is not the obverse of evil, and a full acknowledgment of both isn't needed to achieve balance in the world. For harmony, good must simply rule evil.

And the corollaries to that are endless. White doesn't equal black, male doesn't equal female, culture doesn't equal nature Something is always better than. Despite its name, the binary contains a hidden third term that accounts for the superiority of one side of the binary over the other. It's the thing that has been "passed through," the thing that has been experienced or received, that makes it higher in value, like the blessing of Abel over Cain, or of Jacob over Esau. The Western binary isn't really a two—it's

a three, with an implied beginning, middle, and end. It's a narrative that goes from fallen to saved.

VISITOR: You mean the binary is a triptych, not a diptych …

O'GRADY: Yes, I think you could say so …. The diptych may have two panels, but it's nothing like the binary, in that it isn't "either/or." There's no implied before and after, no being saved. The diptych is always "both/and," at the same time. And with no resolution, you just have to stand there and deal.

exhibit B (2018)

notes on the diptych, 2018
Excerpts from emails, notes, and interviews

If you had told me when I started forty years ago that the form of my work would prove to be more important than the content, I would probably have laughed. But the diptych, whether expressed or implied, has always been my primary form, even in the performances and videos where there is always more than one idea, more

than one emotion at a time. For me, the diptych can only be "both/and." When you put two things that are related yet dissimilar in a position of equality on the wall, they set up a ceaseless and unresolvable conversation. The diptych, appearances to the contrary, is anti-dualistic. That's why it's been my weapon of choice to oppose the West's "either/or" binary, which is always exclusive and hierarchical. I feel that the "both/and" lack of resolution, an acceptance and embrace of it, is what needs to become the cultural goal.[2]

November 19, 2018

The "haiku diptychs" of *Cutting Out CONYT* allowed me to maintain the tensions between my more explicit and less explicit voices.

Whether personal/political, expressive/ argumentative, inner-directed/outer-directed, or post-black/black, these two voices form the parameters of my work, describing and circumscribing diaspora mind, diaspora experience.

Ultimately, there was no extrication of the personal from the political, the expressive from the argumentative, because these qualities were not opposites, but obverse and reverse sides of the same coin. The diptych structure and the surrealist tone both express and argue the

dichotomy. Even categorizing or referring to the divisions and splits feels like a regression back to hierarchies, submitting to the binaries, not overcoming them.
May 22, 2018

In the end, I may just have lucked out. The newspaper poem's surrealist language is constantly exploding at the edges of the mind. You understand it for a moment. Then no sooner than you fall in love, it disappears. And you have to start over again. It was like some crazy objective correlative to the diptych's endless, elliptical movement. But it was beautiful. And it was the best, firmest example of "both/and" thinking I'd had.
October 26, 2018

Notes

1 Toni Morrison, "A Humanist View," May 30, 1975, Portland State Black Studies Center, transcript, https://www.mackenzian.com /wp-content/uploads/2014/07/Transcript _PortlandState_TMorrison.pdf.

2 Lorraine O'Grady, revised excerpt from "Lorraine O'Grady on Creating a Counter-Confessional Poetry," interview by Lauren O'Neill-Butler, *Artforum*, November 19, 2018, https://www.artforum.com/interviews /lorraine-o-8217-grady-on-creating-a -counter-confessional-poetry-77735.

Destiny Manifested I, II, III, IV
by Charles Lee

Optical Illusions: Images of
Miscegenation in Nineteenth- and
Twentieth-Century American Art
by Judith Wilson

miscegenation n. *[Latin miscere to mix + genus
race …]: a mixture of races; esp: marriage or
cohabitation between a white person and a member of
another race.*
—Webster's Seventh New Collegiate Dictionary

*Today, most physical anthropologists do not believe
that pure races ever existed.*
—Bruce G. Trigger[1]

*What the matter came down to, of course, was visi-
bility. Anyone whose appearance discernibly connected
him with the Negro was held to be such.*
—Winthrop Jordan[2]

"Race" is a peculiarly optical system of classi-
fication, as Hugh Honour and Albert Boime
have observed.[3] In the English-speaking world,
it is a concept that characteristically stresses a
single feature of color—value—and is structured

by polarities: "white" and "black," "white" and "non-white," "the white race" and "the darker races," or "white people" and "people of color."[4] Miscegenation, the sexual union of individuals assigned to different racial categories, blurs such distinctions, thereby threatening race-based systems of social order and privilege. Indeed, as both anthropologist Bruce Trigger and philosopher Anthony Appiah have suggested, the age-old historical fact of miscegenation undermines the validity of race as either a scientific or a philosophical construct.[5]

North American attitudes toward race are notoriously rigid and denial oriented in their insistence upon what anthropologist Virginia R. Dominguez has labeled "the binary system":

> Whereas descendants of Africans and Europeans in the United States, regardless of miscegenation, are typically allowed membership in only two racial categories—white and black—the Afro-Latin world ... has long used miscegenation as a mechanism for the construction of a new category of people epistemologically separate from both whites and blacks.[6]

North American practice is unique, too, in its

tendency to view miscegenation primarily in African- versus European American terms—a tendency that both excludes additional levels of genealogical complexity (e.g., the possibility of African, European, *and* Native American ancestry) and erases other histories (e.g., the record of anti-Asian sentiment and legislation, with its accompanying prohibitions of interracial sex). Thus reduced to a black-white issue, the sex-race conjunction has given rise to forms of literary and cinematic representation that are well known: American authors ranging from James Fenimore Cooper to William Faulkner have shared a preoccupation with the supposed tragedy of mixed ancestry, and filmmakers ranging from D. W. Griffith to Spike Lee have lamented the alleged horrors of interracial sex.[7]

In the visual arts, however, miscegenation has been a relatively rare subject, generating little artistic production and even less art historical analysis.[8] While a classificatory obsession with the fruits of contact between Africans, Europeans, and Indians apparently spawned an entire genre of painting in eighteenth-century Mexico and Peru, corresponding works by North Americans are few. To the extent that they occur at all, such images in the United States seem to cluster around two historical fulcrums: the pre- and post-Civil War

debate about race relations and the African-American revolt against existing racial hierarchies during the second half of the twentieth century.

Notes

1 Bruce G. Trigger, "Nubian, Negro, Black, Nilotic?" in *Africa in Antiquity: The Arts of Ancient Nubia and the Sudan*, vol. 1 (Brooklyn, NY: Brooklyn Museum, 1978), 27.

2 Winthrop Jordan, *White Over Black: American Attitudes Toward the Negro, 1550–1812* (New York, NY: W. W. Norton, 1977), 168.

3 See Hugh Honour, *From the American Revolution to World War I*, pt. 1, vol. 4 of Ladislas Bugner, ed., *The Image of the Black in Western Art* (Cambridge, MA: Harvard University Press, 1989), 12; and Albert Boime, *The Art of Exclusion: Representing Blacks in the Nineteenth Century* (Washington, DC: Smithsonian Institution Press, 1990), 1–2.

4 Three facts demonstrate the emphasis on color value in our conceptions of "race": (1) Only two of the terms designating the principal racial categories—red and yellow—possess hue, black and white being achromatic. (2) Racial lore appears to make little or nothing

of color saturation with respect to the so-called red and yellow races; only the alleged density of skin pigmentation among blacks and a contrasting pigmentary translucence among whites are occasionally cited as evidence of corresponding ethical, aesthetic, or intellectual traits. (3) Throughout the era of scientific racism (ca. 1700–1945), comparisons of the world's alleged races tended to conform to a hierarchy—descending from white to yellow to red to black—that constitutes a light-to-dark value scale. Even today, when people of African, Asian, and Native American descent are lumped together as "people of color" (the current, less pejorative alternative to the older "darker races"), an implicit contrast with racial whiteness, curiously perceived as an absence of color and presumed to be the biological norm, is always already at play.

5 Trigger, 27; Anthony Appiah, "The Uncompleted Argument: DuBois and the Illusion of Race," in *"Race, Writing, and Difference*, ed. Henry Louis Gates, Jr. (Chicago, IL: University of Chicago Press, 1986), 21–22, 27, n. 10.

6 Virginia R. Dominguez, "Of Other Peoples: Beyond the 'Salvage' Paradigm," in *DIA Art Foundation: Discussions in Contemporary Culture*,

ed. Hal Foster (Seattle, WA: Bay Press, 1987), 132–33.

7 According to Sterling Brown, the character Cora Munro in Cooper's *The Last of the Mohicans* (1826) was American literature's first "tragic octoroon"; see Brown, *The Negro in American Fiction in Negro Poetry and Drama and the Negro in American Fiction* (New York, NY: Atheneum, 1969), 8.

8 Among the rare instances are Honour's discussion of the "horror of sexual relations between black men and white women" resulting from late eighteenth-century physiognomic studies and their subsequent effect on nineteenth-century paintings of the Shakespeare character Othello. See also his remarks on Delacroix's *Portrait of Aspasie, the Mulatto Woman* (ca. 1824, Musée Fabre, Montpellier, France); the entire chapter entitled "The Seductions of Slavery"; and his assertion, with respect to the Dutch artist Cornelis Johannes "Kees" Maks's early twentieth-century painting of a biracial family, that "a visceral horror of 'miscegenation' exacerbated by colonialist propaganda still prevailed" in Europe even at this late date, "limiting reference to it in works of art." Honour, pt. 2, 16–17, 36–38, 145–86, 215–16.

Between That Event and This Memory: Tradition by David Scott

I would like to propose that we attempt to change this anthropological problematic alto-gether, this sustained preoccupation with the corroboration or verification of authentic pasts. The issue has nothing to do with erasing either of the figures of Africa or slavery (or even the resonant narrative of continuity that embodies them) from the anthropology of peoples of African descent in the New World. Rather, what I propose is their theoretical relocation; between that event (Africa or slavery) and this memory there spreads a complex discursive field we may usefully call "tradition."[1] By tradition I have in mind a differentiated field of discourse whose unity, such as it is, resides not in anthro-pologically authenticated traces, but in its being constructed around a distinctive group of tropes or figures, which together perform quite specific kinds of rhetorical labor.

The first and most obvious of tradition's labors is to secure connections among a past, a

present, and a future. In the theoretical field oc-
cupied by the work of Herskovits and Price, the
figures of Africa and slavery circulate as authentic
presences, which anthropology is supposed to
make legible in the practices or consciousnesses
of the descendants of Africans and slaves. The
project I commend would be concerned with
the following kinds of questions: What are the
varying ways in which Africa and slavery are em-
ployed by New World peoples of African descent
in the narrative construction of relations among
pasts, presents, and futures? What, in each case,
are the salient features with which these figures
are inscribed? What is the rhetorical or, if you
like, ideological, work that they are made to
perform in the varied instances and occasions in
which they are brought into play? For example,
the "first-time" of Rastafarians in Jamaica (and
Rastafarians do speak of "first-time"), like that of
the Saramakas, turns on the central figure of slav-
ery; but it is likely to be inscribed with a different
set of ideological investments, reflecting its
own specific historical and political conditions.
What would be at stake here is less whether one
can measure the extent to which this disaporan
community of Rastafarians retains an accurate
memory of any verifiable preemancipation event
than the ways in which this figure, slavery (and
those figures metaphorically and metonymically

connected to it), enables (or prevents) establishment of positions in a cultural and political field.

Cultural traditions, however, are not only authored; they are authorized. They not only make intelligible; they make legitimate. The second of tradition's labors therefore has to do with securing what we might call a distinctive community of adherents. What space do Africa and slavery occupy in the political economy of local discourse? To what kinds of authority do they make their appeal? From what kinds of audience do they seek their support? What are the conditions—discursive and nondiscursive—of reception that facilitate their persuasiveness? Take, for example, the uses of the figure of Africa by Arthur Schomburg (the bibliophile) and Marcus Garvey (the mass leader), or again, its uses in the verses of a Calypsonian, on the one hand, and the political rhetoric of a Michael Manley, on the other. The point is that this figure can have different political uses, different modes of authorization, can address itself to a variety of audiences—and yet at the same time belong to a distinctive tradition insofar as a single figure is being employed in the construction of a relation between pasts and presents.

The third of tradition's labors is to link narratives of the past to narratives of identity. This

is of course because tradition seeks not only to make the past intelligible and legitimate but also to instruct, that is to say, to actively cultivate the virtues it valorizes. How are the figures of Africa and Slavery employed in the fashioning of specific virtues, in the cultivation of specific dispositions, specific modes of address, specific styles—of dress, of speech, of song, of the body's movements; how, in other words, do these figures participate in those techniques by means of which the construction of appropriate bodies and selves are effected?

It seems to me that these kinds of questions enable us to ask theoretically more interesting questions about pasts in the present. It might be noted too that they are not, on the one hand, essentialist, inasmuch as they do not presuppose the full or partial presence of an Africa or slavery that needs only to pass through the interpretive grid of anthropology to be recognized and appreciated as such. Nor, on the other hand, are they antiessentialist, inasmuch as they do not assert that there is no actual continuity between Africa or slavery and the present, that these are merely empty signifiers. These questions in fact do not seek to make any claims whatsoever regarding the ultimate ontological status of Africa and slavery in the present of the cultures

of the New World and therefore do not see the theoretical task of anthropological inquiry as trying either to accurately represent the proximity between the present and the past or to deny it. At the same time, these questions affirm that peoples of African descent in the New World do make of Africa and slavery a profound presence in their cultural worlds, and seek rather to describe the tradition of discourse in which they participate, the local network of power and knowledge in which they are employed, and the kinds of identities they serve to fashion.

Note

1 See Asad for an instructive deliberation on the concept of "tradition" in relation to Islam. Talal Asad, *The Idea of an Anthropology of Islam*, Occasional Papers Series (Washington, DC: Center for Contemporary Arab Studies, 1986).

inner eye
by Erica Deeman

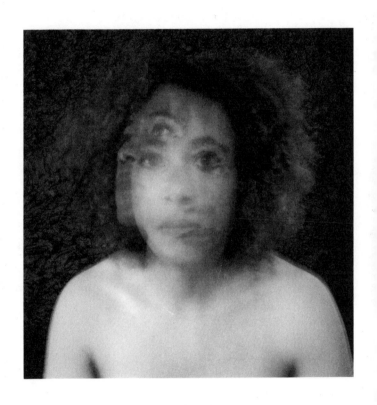

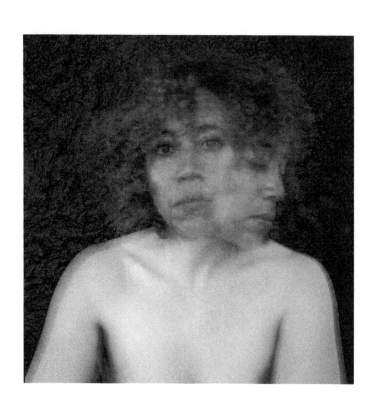

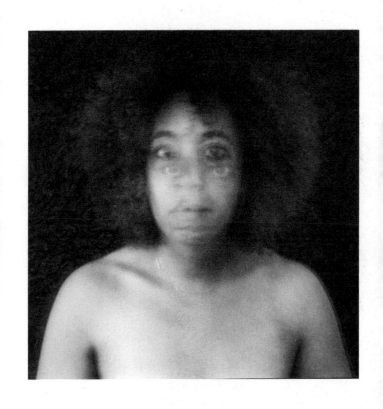

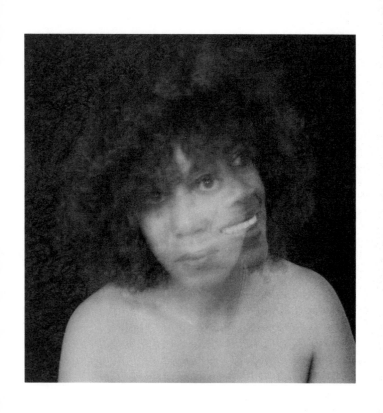

Outline of *Black Athena*:
The Afroasiatic Roots of Classical Culture Historiography and the Project as a Whole
by Martin Bernal

Black Athena is about the origins of Ancient Greece. This concern, then, is Eurocentric to the extent that Ancient Greece has been the most important single contributor to later Western European culture, either directly, or through Rome, Byzantium, and Islam. In investigating Greek origins, I have found it useful to set up two schemes, which I have called the "Ancient" and "Aryan" models. By "model" I merely mean a reduced representation, and this naturally involves oversimplification and distortion of some of the varied complexities of reality. The same can be said, however, of words themselves; just as with words, models are necessary symbols for a coherent representation of reality.

Most readers born before 1970 will have been educated in the Aryan model, which holds that ancient Greek culture developed as the result of one or more invasions from the north by Indo-European speakers or "Hellenes." These

invaders are supposed to have conquered the native population, who are seen as having been sophisticated but soft. Their name having been lost, late-nineteenth-century promoters of the Aryan model called them "Pre-Hellenes." Although it is affirmed that the Pre-Hellenes were "white" or "Caucasian" and definitely not "Semitic" or "African," very little is known about them except for what can be reconstructed from supposed linguistic traces of their culture in Greek language and proper names.

Greek is an Indo-European language; its phonetic and grammatical structures conform with relative regularity to those of the other extant ancient members of the large linguistic family that includes Sanskrit, Latin, and many other languages. Greek, however, is unusual in the very high percentage of its vocabulary—more than 60 percent—that cannot be explained in terms of other Indo-European languages.[1] This pattern can be explained by the Aryan model, according to which most of the non-Indo-European words and names are attributed to the Pre-Hellenes. The serious difficulties presented by this scheme are discussed in my response to Jasanoff and Nussbaum.[2] The Aryan model does not claim that Greek as a language was homogeneous, or that the Greeks were

pure "Indo-Europeans" or "Aryans." Instead, its proponents agree that there was linguistic mixing but insist that both invaders and natives were "Caucasian" or "European."

In this way, the picture produced of Ancient Greece is different from that of the Aryan conquest of India, because the original pre-Aryan inhabitants of the Indian subcontinent were "dark." Thus, despite what nineteenth-century historians saw as noble attempts to preserve their race through the caste system, the Aryans who conquered India suffered "racial degradation." The origin of Greece, in contrast, was imagined as having been more like the Germanic destruction of the Western Roman Empire, events that historians of the nineteenth and early twentieth centuries portrayed as Teutons infusing vigor into a Celtic and Roman *European* population. However, although the Germanic invasions were unquestionable historical events—and there is also strong legendary and linguistic evidence to suggest that there were Aryan conquests in Northern India—evidence for a similar conquest is completely lacking in the case of Greece.

The Ancient model, which is very different, was referred to by the playwrights Aeschylus and Euripides, the historians Herodotus and Diodorus Siculus, the orator Isocrates, the

guidebook writer Pausanias, and the mythographers Apollodorus, Palaiphatos, and Konōn. It was omitted by one or two writers in contexts where they might have mentioned it, but was denied only by Plutarch in what is generally seen as an outburst of spleen against Herodotus. In other writings, Plutarch admitted Greece's deep cultural debts to Egypt; he took it as axiomatic, for instance, that Greek religion came from Egypt.

According to the Ancient model, Greece had once been inhabited by primitive tribes, Pelasgians and others. Certain regions, notably Boiotia and the Eastern Peloponnese, had then been settled by Egyptians and Phoenicians who had built cities and civilized the natives. The Phoenicians, for instance, had introduced the alphabet, and the Egyptians had taught the Pelasgians such things as irrigation, the names of the gods, and how to worship them.[3]

This Ancient model was not doubted until the end of the eighteenth century, and it was not seriously challenged until the 1820s. Only then did Northern European scholars begin to deny the ancient colonizations and play down Egyptian and Phoenician cultural influences on Greece. These historiographical developments cannot be linked to the availability of any

new evidence. The great discoveries of the nineteenth century—the first archaeology of Bronze Age Greece by Heinrich Schliemann and the decipherment of cuneiform—took place many decades after the change of models. Jean-François Champollion had begun to decipher hieroglyphics in the 1820s, but the scholars who overthrew the Ancient model drew little from his work. Readings of Egyptian texts were not generally accepted by classicists until the 1850s. The reasons for the overthrow of the Ancient model are to be found not in internal developments within the disciplines, but in the intellectual milieu of the time.

The years from 1815 to 1830 were outstanding throughout Europe for political reaction and religious revival. Both of these movements were opposed to the Enlightenment and the French Revolution that was seen as its offspring. Thus, the reaction against Ancient Egypt during these years should be seen in the light of Egypt's centrality to the beliefs of the Freemasons—see for example the Masonic trappings of Mozart's *Magic Flute*. The Enlightenment in general and the Freemasons in particular were seen by reactionaries to have been at the heart of the French Revolution and specifically to have been behind its anti-Christian "religion of reason."

In the long run, however, the Ancient model was destroyed not because of any threat to Christianity from the Freemasons but because of the predominance, in the nineteenth century, of the linked concepts of progress, romanticism, and racism. For the progressives, Ancient Egypt lost ground to Ancient Greece because the former was older and, hence, at an earlier stage of evolution. Egypt's stable centralized government did not appeal to the romantic love of small communities with turbulent histories. At first, the racism of the Enlightenment did not affect the reputation of the Egyptians because they were granted honorary European status. After the 1790s, however, both radicals and romantics began to view Egypt as increasingly African.[4]

In the new period of systematic racism, the eighteenth-century image of the Greeks changed progressively from that of intermediaries who had transmitted some part of the civilization and wisdom of the "East" to the "West" into that of the very creators of civilization. At the beginning of the eighteenth century, the Ancient Greeks were admired because of Homer and the later poets. In the middle of that century, cultivated Europeans, led by the connoisseur Johann Winkelmann, began to see Greek art as the highest ever achieved. Finally, in the 1780s,

historians of philosophy came to agree that there had been no philosophy before the Greeks. This apparent triple achievement—of epic poetry characteristic of the "childhood of a race," art associated with flowering youth, and wisdom that came with its maturity—gave the Ancient Greeks a superhuman status as the models of balanced and integrated humanity.

This feeling was particularly strong in Germany. There, during the eighteenth century, intellectuals sought to preserve their cultural identity from French *Zivilisation*. The French threat was backed not only by the power and brilliance of contemporary Paris and Versailles but also by the *Roman* Catholic Church and Rome itself. In response, German thinkers turned to creating a sophisticated German language purged of Latinisms and to developing the romantic concept of an ineffable German *Kultur* seen as local, deep, and hidden as opposed to the superficial glitter of *Zivilisation*.[5]

German resistance to the supposed Rome-Paris axis also took the form of Neo-Hellenism. In the sixteenth century, Martin Luther had challenged the Latin Vulgate Bible with both the Greek New Testament and his German translation of the Bible, thereby undercutting the Roman monopoly of Western Christianity

in two ways. In the political and cultural crises of the eighteenth century, enlightened German intellectuals like Christoph Martin Wieland and Johann Wolfgang von Goethe became passionately interested in pagan Greece. Many in their generation concluded that Germany, despite the efforts of Frederick the Great, could never be politically united or militarily powerful as a "New Rome." Nevertheless, with its many squabbling small states but high level of education and culture, it could become a "New Hellas."

German Neo-Hellenism became particularly passionate after 1789, when the French Revolution compounded the menace to Protestant Northern Germany, adding revolutionary ideas to its earlier Catholicism. In 1793, during the trial of Louis XVI, the brilliant young aristocrat and polymath Wilhelm von Humboldt sketched out a plan for a new education that would reintegrate men and women spiritually torn apart and alienated by modernity. This reintegration would be accomplished with the help of study of what Humboldt saw as the most perfectly integrated people of the past: the Ancient Greeks. In 1806, the Prussian government, in panic after its military humiliation by Napoleon at Jena, appointed a reform cabinet. Humboldt was included and put in charge of national education. In

this way, he was able to implement many of his earlier ideas, as well as establish the humanistic education of the *Gymnasium* and the university *Seminar* focused on *Altertumswissenschaft*, the "study/science of Antiquity and of the Greeks in particular."[6]

Humboldt seems to have intended his scheme to reach the whole population. Not surprisingly, this did not happen. Nevertheless, the new German educational system, as it was instituted, had clear meritocratic tendencies and was thus a threat to the aristocracy, many of whom opposed the new ideas.[7] Similarly, its English offshoot, "Classics," was seen as a middle way between reaction and revolution. From the beginning, however, the chief purpose of the Germans and English who advocated a humanistic education focused on Ancient Greece was not to attack the ruling class but to forestall or avoid revolution. Indeed, despite some trouble from the radicals associated with the Philhellenic movement in support of the Greek War of Independence, humanistic education has very effectively maintained the status quo.

[...]

In some ways, it is useful to see late-nineteenth-century "racial" anti-Semitism as a luxury that Gentile Europeans and their American

"cousins" could afford only when the rest of the world was utterly crushed. One major factor behind the rise of Western anti-Semitism in the 1880s and 1890s was the massive migration of East European Jews into Western Europe and America. But another was the extraordinary arrogance associated with the triumphs of imperialism. It was during these decades that belief in the Phoenicians' formative role in the creation of Greek civilization plummeted. Concomitantly, this period saw not only the Dreyfus affair but also the publication of influential scholarly articles denying that there

had ever been any significant extra-European influence on the formation of Greece. The Broad Aryan model survived, however, until the decade 1925–35, when Western scholarship firmly put the "Semites," both Jews and Phoenicians, in their place: outside Europe. In contrast to the earlier period, the lessening of European self-confidence after the First World War now served to increase anti-Semitism. Furthermore, in 1917, anti-Semitism was driven to fever pitch by the perceived and actual importance of Jews in the Russian Revolution and world communism.[8]

Although I maintain that the "externalist" forces described above provided the chief impetus for the shift of models, and the only one

for the destruction of the Ancient model, an important "internalist" impulse also lay behind the creation of the Aryan model in the 1830s and 1840s. This impulse came from the working out of the Indo-European language family and the plausible belief that at some time a single Proto-Indo-European language was spoken somewhere to the north of the Black Sea. Thus, as Greek was an Indo-European language, it must, at some stage, have been introduced from the north. Using this argument, advocates were able to postulate an "Aryan invasion"—despite the absence of any archaeological evidence or ancient authority—and thus satisfy externalist demands. The ideological forces behind the shift are shown by the increasing insistence of the proponents of the Aryan model that the northern and southern influences were mutually exclusive. I am convinced that this insistence came from the romantic desire for purity and the association of such purity with the north. No other reason can explain the inability to form the plausible hypothesis that Greece had been substantially influenced from both directions. This dual influence—and not a sole influence from the south and east—is what I propose in my "Revised Ancient model."

The situation has changed sharply since

1945, partly because of the moral revulsion at the consequences of anti-Semitism seen in the Holocaust. Sadly, I believe that the simultaneous rise of the "Third World" and of Israel as a bastion of the "First World" or "Western Civilization" has had an even greater impact on European and Euro-American academic opinion. Concretely, Israel's military triumphs have removed the stereotype, common at the beginning of this century, that "Semites," or at least Phoenicians and Jews (as it was never possible to include Arabs), were "racially" determined to be passive merchants and were, therefore, biologically incapable of the military actions attributed to them in Greek legends.

The events of the 1940s and 1950s led toward the readmission of Jews as Europeans. Among Jews in both the United States and Europe, the increased self-confidence has been largely reflected in Zionism and religious revival. At the same time, a very much smaller group has tried to restore the reputation of the Phoenicians. Thus, since the 1960s an attempt to bring back the Broad Aryan model for the origins of Greece has been reemerging. Resistance from the "extreme Aryanists" seems to result largely from inertia and respect for authority, which are naturally very high in such

traditional disciplines as Classics and historical linguistics. Nevertheless, the defenders of the Extreme Aryan model have been weakened both by the changing intellectual climate and by increasing archaeological evidence of Egyptian and Levantine influence in the Aegean during the Late Bronze and Early Iron Ages. The Broad Aryanists are now gaining ground and will almost certainly succeed within the next five years. For instance, the editors of *BAR* now appear to accept the Broad Aryan model, although they still prefer Mesopotamian "East Semites" and the Northern Levant to the "West Semites" of the Southern Levant. The restoration of the Egyptian aspect of the Ancient model, in a revised form, will take somewhat longer; the principal debate is now beginning to be between the Broad Aryan and the Revised Ancient models.

[...]

If on these or any other grounds one prefers the Revised Ancient model, the image of Ancient Greece must be reassessed. We should turn from the image of a civilization springing, like the conventional image of Athena from the head of Zeus, white, virgin, and fully formed, to an image of a new civilization growing up at the intersection of Europe and the Middle East as a thoroughly mixed and eclectic culture. The greatness and extraordinary brilliance of Greek civilization in Antiquity, and the central role it played in the formation of all later European cultures, was not the result of isolation and cultural purity but of frequent contact and stimulus from the many surrounding peoples with the already heterogeneous natives of the Aegean.

Notes

1 For a discussion of this, see Martin Bernal, *Black Athena Writes Back* (Durham, NC: Duke University Press, 2001), ch. 6, n. 51.
2 For a discussion of this, see *Black Athena Writes Back*, ch. 6, nn. 50–57.
3 For this, see Martin Bernal, *Black Athena: The Afroasiatic Roots of Classical Civilization, Vol. 1: The Fabrication of Ancient Greece 1785–1985*

[*BA I*] (London: Free Association Books, 1987), ch. 1.

4 For more discussion of this, see Bishop Thirlwall, *A History of Greece* (London: Longman, Brown, Green & Longmans, 1835–44), 6.

5 Norbert Elias, *The History of Manners, Vol. 1. The Civilising Process* (New York, NY: Urizen Books, 1978), 3–10.

6 This was the title of the famous Skizze (Sketch) on the subject. See *BA I*: 284, 402

7 For a discussion, see *BA I*: 284–88.

8 See Martin Bernal, *Black Athena: The Afroasiatic Roots of Classical Civilization, Vol. 2: The Archaeological and Documentary Evidence* [*BA II*] (London: Free Association Books, 1991), 367–99.

empty, whole, and on the way
by Selam Bekele

like 3 fingers
on a turning
page ...

both

what is

and

what

can

be

132

What land are
you waking me
from my dream?

Linda Goode Bryant
by Rujeko Hockley

LGB

The next year, I'm working at the Studio Museum. The NCA conference that year is gonna be in Chicago, and a lot of the activities are happening in this hotel. I tell Ed that the Studio Museum should be represented at the conference, and so I go to the conference. I'm standing in the lobby of the hotel talking to somebody when Helen Ramsaran, an African American artist, comes running up saying, "Linda! Guess who's here? David Hammons is here." I go up to him, "Uh, Mr. Hammons, I studied your work when I was at Spelman College and back then you wouldn't tell people how you made your body prints, and I'm wondering do you tell people how you make them now?" And he didn't look up; he just said, "Yeah. You do this. You do this. You do that. And you do this." I just said, "Oh thank you," and was about to walk away when he looked up and said, "Got any other questions?" He and I talked all through the night. It was really amazing. At some point

in our conversation, I asked, "When will we be able to see your work in New York City?" And he goes, "I don't show in white galleries."

RH
Where was he living at that time?

LGB
LA. And so I said, "Oh, I guess that means I have to start a gallery."

RH
The only obvious response.

LGB
He goes, "Yeah, you go do that." I had already started [to work towards a gallery of my own] due to my time at the Studio Museum and its Artist-in-Residence program. As director of education, I was responsible for that program. I was seeing and talking with artists all the time. So many of the conversations I had with artists were about how "they won't let us" show in this gallery or this museum, and how "we can't get our work out there for people to see." So I had already reached the point of saying, "Fuck them. Let's just start a gallery ourselves." I was younger, so I was kind of naïve.

RH

They didn't take you seriously?

LGB

Yeah. It really was in that moment with David saying, "I don't show in white galleries," that made me say, "Maybe I'll start a gallery." It was the combination of those two things. Being concerned about what someone else won't let you do? Let's just do it ourselves, and me wanting to see David's work. That was in the spring of 1973, and I went about the process of doing that with zero money. I was still in graduate school, I was working full time at the Studio Museum, I was a single mom who had these two kids, and I said I was gonna start this gallery. I had a lot of connections with artists, and so I started to reach out to those artists whose work I liked.

[...]

At some point I was just ready to make the move. I knew which artists I wanted to show and I started looking for a space. I went to Citibank and asked how much money I could borrow on my salary, which was two thousand dollars a month.

I wanted the space to be somewhere significant because, at that time in New York, there were only a few galleries that represented and showed work by African American artists. Cordier & Ekstrom represented Romare [Bearden]. Terry Dintenfass represented Jacob Lawrence and Raymond Saunders. Andrew Crispo represented Fred Eversley. I started looking for a space on Eighty-Sixth and Broadway, hence the name Just Above Midtown (JAM). I didn't want to be in Harlem or Bed-Stuy or Jamaica, Queens. I wanted to be close to a major gallery district and not in a black community because that's where black artists could show—in community centers if not the Studio Museum. I wanted to be where they weren't shown with other artists. I went to Henry Geldzahler largely because Tom Hoving, the director of the Met at that time, told me to. I had lunch with Henry and he was like, "You can't start a gallery. Black artists only make black velvet paintings. Is that what you're gonna sell?" I said, "I'm looking at a space on Eighty-Sixth and Broadway. I'm gonna have it there on the second floor." He said, "Well, that's really stupid. If you're gonna do a gallery, you should do it in a major gallery district." So I started looking at Fifty-Seventh Street, which was the major gallery district; although SoHo was developing,

the more established galleries were around East and West Fifty-Seventh, and then there was Madison Avenue. I ultimately found the space at 50 West Fifty-Seventh Street, but I should say that every time I called a broker they would ask me, "Well, what do you want to do?" I would say, "Well, I want to start a black gallery." They would hang up the phone or tell me they didn't show black velvet paintings. Finally, I just said I was going to show work by emerging artists or something like that. At the end of my search, I got into the Judson Realty office. Bill Judson was the owner. His guy Peter Marks said, "Come in and see me." I had my babies, didn't have any child care, and so he was a little shocked when I got there. Also, back then I had a huge, huge, huge 'fro, and I wore army fatigues everywhere. I came in with army fatigues and these babies, and his eyes were as big as this. He said, "Oh, so you're the one who called." He gives me the application, goes through the ritual, and you can see this guy is thinking, "Forget about this." I say to him, "So how much does it cost?" And he told me, "$1,000 a month." I said, "Are you kidding? I can't pay that." And so he goes, "Well, that's how much it costs. How much can you pay?" I say, "$300," and he goes, "What?!" I say, "But I don't have that!" And so he says,

"Wait right here." He leaves his office and he comes back with this man, who ends up being Bill Judson. Bill goes, "So my man tells me that you just offered to pay me $300 a month for the fifth-floor space at 50 West Fifty-Seventh Street." I said, "Yeah." And he cut right to the chase. He said, "Why should I lease this to you for $300 a month?" And I said, "Because New York City is bankrupt. You have a lot of empty spaces in that building, and it would seem to me $300 a month is better than nothing." (laughter)

[...]

RH
Tell me about the opening of JAM.

LGB
The opening was unbelievable. It was a first and everybody came out. The space itself was only 724 square feet so the gallery was packed. The first exhibit was a group show called *Synthesis* and it had everybody in it from Norman Lewis to Suzanne Jackson to Valerie Maynard to David [Hammons]. It was a whole bunch of folk in it. Not only was the gallery packed, but the hallway and down the stairwell was packed, and it was on the fifth floor. The lobby was packed,

and it was packed on the Fifty-Seventh Street sidewalk. It was black folks galore, and it was black folks from all of the arts, so Melvin Van Peebles to Vertamae Grosvenor were there. It was the whole gamut. I mean, the actor Brock Peters was there. If you were in the arts, theater, film, dance, or whatever, you were there for the opening of JAM. The energy of JAM really started that night. There were all kinds of arguments and debates. People were fighting amongst themselves about the work that was on the walls. There was just energy, energy, energy, because we were on Fifty-Seventh Street. I didn't mention that on the floor right next to us was Mario the tailor. He was a men's tailor for everyone from Miles Davis to Walt Frazier and a lot of other basketball players, everybody and their grandma. So celebrities were coming in to get fitted for their clothes and saw the gallery when they got off the elevator.

RH
Perfect. This is a good location.

LGB
Who knew? I had no money, so we laid the floor at West Fifty-Seventh Street ourselves. It was linoleum initially, and we laid wood parquet

blocks down over it. I had enough money to buy supplies, and the artists and the curators helped. Other folks loaned money. I just found some financial records in the archive from back then and Lowery Stokes Sims donated money. Folks were just like, "Here take this and let's make this happen." It truly was a community creation. It was a team. It was creative people coming together and saying, "We're gonna make this." We had some money and a lot of debt, and that opened the gallery.

Museum Series
by Carrie Mae Weems

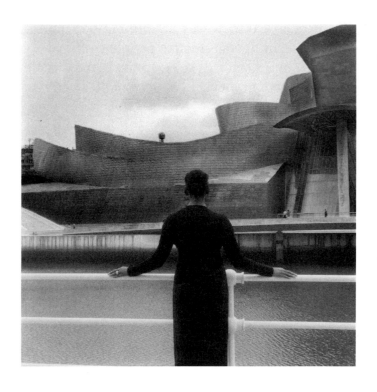

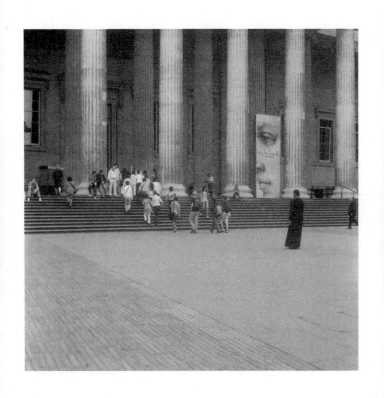

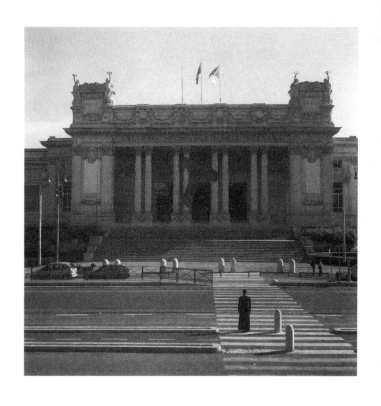

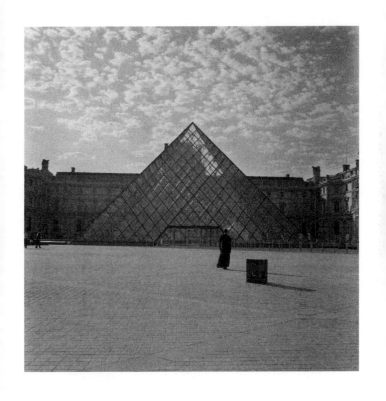

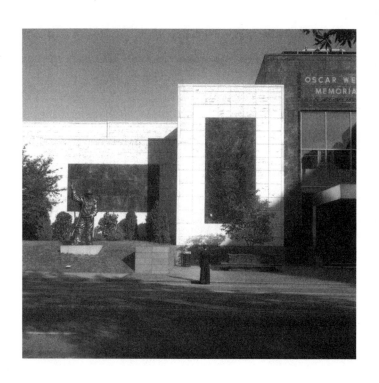

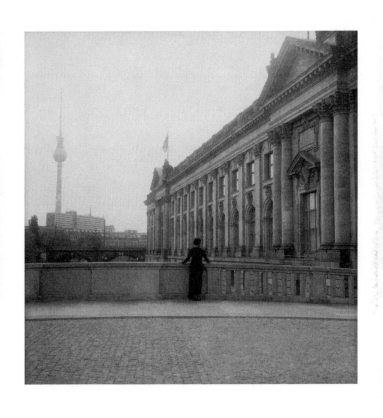

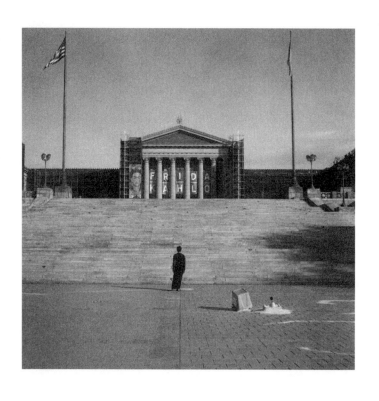

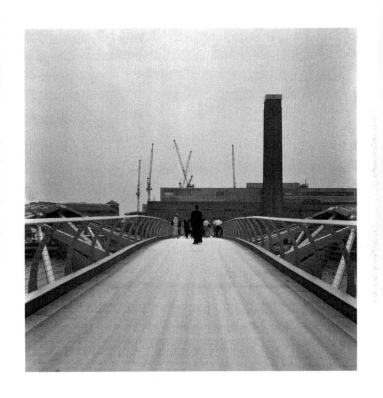

Of Poets, Galleries, New York Passages
by Kathleen Collins

"What did he look like then? Like an Irish poet, thin, dark curly hair. He was always broke. Always running around Paris borrowing money from someone in the Sixteenth Arrondissement. He was handsome. Remarkable for his suits, his elegant open shirts, a thin little mouth that spoke a good spattering of any language on any subject. Considered witty. He was certainly considered witty. Always in good taste…"

They were sitting around the dinner table in a huge SoHo loft. One of those former machine shops now stripped, windows thrown open to the sun, ingenious rooms carved out of cavernous space, a cozy kitchen with clever cupboards. Something rough, still, in the walls; the too-abundant space concealing old sprinklers and untidy ceilings. There were three of them: Ellen, who tomorrow would have her first one-woman show; Mickey, a painter of reasonable standing though remarkable talent; Louise, a friend from the country. The friend to whom they constantly referred was Edouardo, who had

come to dinner the night before and slapped Louise rather viciously across the face.

"He's become quite mad," Mickey said, "though he's always had it in him. Once, in Paris, he chased me out of a restaurant for some chance remark that offended him. Caught up with me and clawed my face with his nails." He smiled at Louise. "But you, why you've always been the princess for him, it's always Louise who can do no wrong. He keeps you fresh. Like the one unsoiled memory dating all the way back to Paris. 'Louise became something …' that's his favorite way of putting it … 'Louise became something.'"

Ellen laughed. Her laughter had the irrelevant taint of a stranger to the past. As indeed she was. Her affection for Mickey was the only link to the trio that held between them common memories of fifteen-odd years of friendship. "Edouardo's a shit," she said. "I know you forgive him because you remember the curly hair, the elegant poverty-stricken days, but really he's a shit."

"A shit …" Mickey said, giving the idea careful consideration. "Do you agree?" he asked Louise.

"He used to write poems." Louise sighed.

"Aw, come off it, honey," Ellen said, and

laughed. "No one's ever seen a line! Oh, he drops his little hints. When he's in one of his sensitive moods he alludes to quiet meanderings down poetry lane, and I say, 'Listen, Edouardo, one of my real pleasures would be to read a bit of your quiet verse, I'd love it, believe me, I'd love it.' Then he sighs. 'Yes, perhaps one day we shall,' he says, and folds that subject neatly back into his too-tight pants."

"Ellen can be a bit rough when it comes to Edouardo," Mickey apologized, hugging Louise. "Listen, Louise, have you any idea how good it is to see you? You never set foot outside that happily-ever-after in suburbia, and here we've got you for three whole days in New York. You'll see Ellen's show, we'll smuggle you in and out of a few choice bars, we'll try to overlook last night's brutal mugging. How's your eye?"

"I can feel it," Louise answered gently.

"You look good," Mickey soothed, "you look young with your five children, your poems and plays, you have the fertile look of someone happy-ever-after …"

"You've really got this thing about my living in the country." Louise laughed.

"It's so healthy, it reeks of healthiness: fresh air and trees, little budding brooks and howling children …"

"I have nowhere *near* five children," Louise insisted.

"But you're always producing ... books, plays, children ... all you do is sprawl out under trees and breed." Mickey laughed.

Louise smiled. "You're just attached to this idea that I lead a simple existence—"

"Listen, dearie," Ellen interrupted, "you should hear Edouardo on the subject of your graceful existence. 'Louise has achieved a life ...' that's one of his favorite expressions about you ... 'Louise has taken the measure of things and achieved a life.'" She lit another cigarette.

She was a short, dark woman with ravenous eyes and the stubby, fat fingers that often belong to painters. There was almost a physical resemblance between her and Mickey. He, too, was short, with pale, scruffy good looks, a boyish affect, brash and intent. Beside them Louise had a handsome, placid surface.

Mickey hugged Louise again. When he was a little drunk his affectionate need to touch and handle be came more intense. "You're so fertile, I feel if I squeeze you too hard you'll reproduce right here at the table."

Louise burst out laughing. "What a lot of ideas you hang around me ... Why do you burden me with ideas about me?"

153

"You don't admit you're fertile," he insisted.

"I'm not a cow." She laughed again.

"Then you refuse to acknowledge a certain pastoral earthiness," he persisted.

"Good God," Louise cried, "I'm just an old friend who happens to live in the country. Perhaps I'm a shade more at ease than I might be if I still lived in New York."

Louise lowered her head and drank her wine. Mickey continued to stare at her with intense affection. Ellen busied herself preparing Turkish coffee and dessert.

"Tell me more about Edouardo," Louise asked quietly.

"There's the museum," Mickey answered. "Every one says they'd like to drop him but they keep him on as fourth curator or some such nonsense. He's invited to the right openings."

"Usually with Henrietta," Ellen added.

"He's made a bit of a name for himself," Mickey continued. "He collects paintings. Does it with a bit of splash, too. He's got a few of mine. Two of my best, in fact."

"How do you feel about his owning your work?" Louise asked.

"He makes a very big deal about it," Mickey answered irritably. "Don't misunderstand, other people buy my work, but with him I'm forced to

154

remember it—frequently."

"Edouardo tallies things up," Ellen said.

"Listen, if he doesn't buy something from your show you'll be in a state," Mickey said to her.

"Not quite that intense," Ellen answered. "It's Ricardo who's counting on it."

"Ricardo's her gallery owner," Mickey explained to Louise. "They're like high-class salesmen ... Art has become a fashion show: chic openings, brittle cocktail parties—the decorative impulse reigns." He looked at Ellen. "I'm not talking about you ... Her work is good, the real thing," he said to Louise. Then he raised his glass. "A toast to Ellen's show. It's a good gallery and that still means something in New York."

Ellen waved her glass in the air. "It means all the parasites came out to suck your blood, dearie, that's exactly what it means."

"You're tough," Mickey said to her. "She's a tough lady," he added to Louise.

"Look who's talking"—Ellen laughed—"the Lone Ranger of the art world!"

Mickey lunged forward into Ellen's face. "Is that how I'm regarded?"

"That is exactly how you're regarded and you love it." Ellen laughed again.

"She thinks she knows me," Mickey said to

Louise. "She's a witch … though it's true I'm not interested in fashion."

"Nobody could accuse you of that, dearie," Ellen said. "All those stubborn little fingers know how to do is paint well. He's a genius," she added to Louise.

"And she's a witch." Mickey laughed, a raucous undercurrent of wine-sated delight taking hold. "I'm in the presence of two abundantly fertile women," he roared.

"Oh God," Ellen groaned, "I feel like a giant duck …" Louise broke into hysterics. "Can you believe this routine?" Ellen said to her. The women giggled.

Mickey stared at them as if at some dazzling unknown species. "Look at the two of you," he fairly shouted, "you create, you breed, you smile, you even hold on to your glamour."

"And at midnight we turn back into witches." Ellen chuckled.

"We make wonderful photographs." Louise bowed luxuriously.

"Listen, dearie," Ellen continued, "I bet right now Edouardo's got that fast left to your eye incarnated in same delicate lyric sonata."

"The light that fell on Louise is gone." Louise flourished dramatically.

"A fitting epitaph to your fall from grace,"

Ellen approved, and the women laughed outright.

Mickey continued to stare at them with fascination. "You've had husbands," he suddenly said.

"We have!" they chimed back instinctively, overcome by a kind of giddy inexplicable hysteria.

"Yours was a poet," Mickey said to Louise.

Louise nodded. "With one of those handsome abstract faces that go well with poets. You once told Edouardo you didn't approve of my husband," she said, and giggled.

"He told you that?"

"Over one of those dinners where he was concerned about the state of my life he said to me, 'Mickey has never approved of your husband.'"

"And how did you feel about that?"

"It struck me. Edouardo has a way of declaring his opinions, and obviously he shared that one. As though they were facts and everything should change accordingly. In a word, it was time I divorced my husband at once."

"But you didn't."

"Not for many years ... though it was soon after that I decided to move to the country."

"And began the life that Edouardo so admires." Louise smiled. "It isn't a lie."

"Louise lives on excellent terms with her

solitude." Ellen giggled.

"Is that Edouardo talking?" Louise laughed.

"As close as I could get without him walking through that door …"

"I'm a photograph …"

"Royalty … "

"But I've got a black eye!"

"Louise has achieved a certain humility." Ellen bowed grandly. "It was time for Louise to achieve a certain humility …"

#BookReport
by Jeanne Finley and John Muse

Over the course of the *Mad Men* series, Don Draper is
seen reading twelve books. He is often interrupted,

usually by a woman.

Exodus, by Leon Uris (Episode 106)
The Best of Everything, by Rona Jaffe (Episode 106)
Meditations in an Emergency, by Frank O'Hara (Episode 201)
The Sound and the Fury, by William Faulkner (Episode 211)
The Chrysanthemum and the Sword, by Ruth Benedict (Episode 405)
The Spy Who Came in from the Cold, by John le Carré (Episode 413)
The Fixer, by Bernard Malamud (Episode 507)
The Berlitz Self-Teacher: French (Episode 507)
Odds Against, by Dick Francis (Episode 509)
The Inferno, by Dante Alighieri (Episode 601-2)
The Last Picture Show, by Larry McMurtry (Episode 607)
Portnoy's Complaint, by Philip Roth (Episode 704)

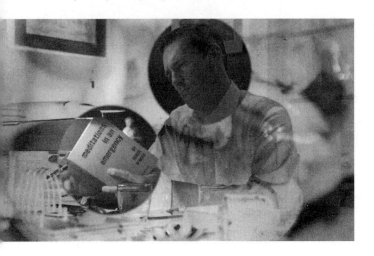

Don Draper reads Frank O'Hara:

Now I am quietly waiting for
the catastrophe of my personali-
ty
to seem beautiful again,
and interesting, and modern.

The country is grey and
brown and white in trees,
snows and skies of laughts

It may be the coldest day of the year, what does he think of that? I mean, what do I? And if I do, perhaps I am myself again.

"Yeah, that's you. With the silver, bronze, and gold. You better use some candy, some Tic-Tacs, some wax paper and cheese, just in case, just in case you're a monster, just in case you start grab-

In June of 2016, the presidential candidate's campaign pays $35,000 for web advertising to Draper Sterling, a consulting firm named after the fictional ad agency in *Mad Men*. No one knows what Draper Sterling actually does, but it is run by a medical equipment salesman who poses as a "naughty chef" with an artificial penis. His wife says he bought it in Mexico, adding, "They had no Caucasian ones."

In the episode *To Have and to Hold*, Draper shows up on set where his wife Megan is shooting a love scene. He says to her, "You kiss people for money. You know who does that?"

bing, just in case you start kissing the pavement, just in case you start bleeding. You know her. You know her from Palm Beach. Actually, you don't know her, but I do. You don't know anyone. You're automatically, painfully, crimi-nally attracted to and dis-gusted by yourself."

After the second 2016 presidential debates, St. Louis Alderman Antonio French tweets, "His foreign policy answers sound like a teenager who hasn't read the book. 'Oh the grapes. They had so much wrath.'" Twitter users begin posting book reports in the idiom of the candidate, using the hashtag #trumpbookreport. There are sixty tweets on Dante's *Inferno*.

"Take off your coat. Pick up her books. You just start kissing, grabbing, begging, apologizing to them. They're like a magnet, like a bar of soap, like a leather strap, like a razor blade, like a donut. Just kiss. Just die. Just give up. You have to wait."

"You just start apologizing to them. They're like an English muffin, like a French fry, like a leather strap, like a razor blade. They burn you to the ground, they make

Portnoy's Complaint, by Philip Roth, is read by Draper in the episode entitled *Monolith* and has thirty-three "book reports." "Portnoy could've just gone out and grabbed a woman instead of grab-bing himself all the time. Loser. Sad. #trumpbookreport," October 20, 2016.

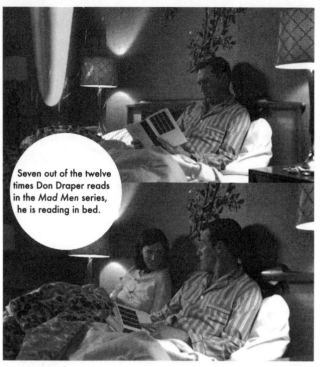

Seven out of the twelve times Don Draper reads in the *Mad Men* series, he is reading in bed.

you bleed. You want her attention. She grabs your attention. She grabs you. She grabs you where it hurts. She crushes your teeth. You're dying. You're dying alone, kissing the pavement, kissing the silver, bronze, and gold. Really. You have to move over. Move under her thumb, on her terms, at the end of her sword. You want to burn it down. I don't, but you do. You try, but you can't. So she flew downtown.

Draper demands that Sylvia wait in a hotel room. "You exist in this room for my pleasure."

Forty-five minutes after take-off, the real estate tycoon lifts the armrest, grabs her breasts, and puts his hand up her skirt. "He was like an octopus."

"I like to read on planes. I don't like to talk."

You flew down to Palm Beach."

"You were nervous. You moved and you failed. You will always fail. You have failed her. But you can't admit it. To anyone. She wanted to get some. She wanted to get some furniture in Palm Beach, and you moved. It was hot in Palm Beach. You moved her furniture. You moved in with her. With her chairs and tables. With her forks and hair-spray. You moved on her furniture. Like the dog that you are. But you couldn't. You couldn't get there."

"You found the furniture. You

"Honey it's hot. And I have to read this book about the desert."

found the carpet. You pissed on the carpet. Like a dog. She was married. You were married. Then all of a sudden, she sees you."

In 1991, Ivana tells *Vanity Fair* that the future president keeps a copy of Adolf Hitler's collected speeches next to his bed.

"You're a big phony. Your look changed. She's totally changed your look. She's totally changed you. You try to move. But she's moved on. She left you. She left you on the carpet in Palm Beach. She left you pissing on the carpet in Palm Beach. She moved on you. She moved on you with her forks and hairspray. With her bacon grease and 409. With your fat face on fire. Like the burning, squealing, pissing dog that you are."

This text/image map is based on *Book Report*, a 2017 film by Finley+Muse that interweaves multiple narrative threads: a voice-over derived from the infamous *Access Hollywood* clip where the future president brags about assaulting women: "I don't even wait. And when you're a star, they let you do it, you can do anything…"; sequences from *Mad Men*, a television series set in 1960s New York, featuring Don Draper as the talented creative director of the fictional Sterling Cooper advertising agency; and numerous book reports shared on Twitter in 2016:

You Retweeted
S. E. Despres @sedespres · 20 Oct 2016
This Dante guy, could only come up with nine circles? My Inferno will have ALL THE BEST CIRCLES. YUGE CIRCLES #TrumpBookReport
↩ 4 ⇄ 294 ♥ 745

You Retweeted
Austin Hunt @huntjaustin · 20 Oct 2016
Now, Dante's Inferno, lemme tell ya. That inferno was hot, big league. But not as hot as my daughter. #TrumpBookReport
↩ ⇄ 2 ♥ 10

You Retweeted
Melanated Soul @RealMotha4Ya · 20 Oct 2016
Uncle Tom's Cabin, worst cabin in the inner city. Terrible schools. Nasty women & bad hombres everywhere. @AntonioFrench #trumpbookreport
↩ 25 ⇄ 2.2K ♥ 4.7K

You Retweeted
Cora Huggins @Rangerswife1 · 20 Oct 2016
Charlotte's Web …Spider dies at the end… no stamina. What a loser.
#TrumpBookReport
↩ 10 ⇄ 490 ♥ 979

I Listen to the Radio _
A Catalogue of Encounters:
Three Reflections on Collaboration
by Peter Simensky

AKI ONDA

Aki Onda records the airwaves while visiting new cities. Radio is both place-defining and random. He tells me that his seminal work, *Nam June's Spirit Was Speaking to Me*, will be showing at the Toronto Biennial of Art, so instead he can offer us the two radio field recordings: *Midnight Radio* and *A Method to Its Messiness*. With their discursive found audio, vocal overlays, and static, in the end these are perfect for *Pyrite Radio Dispatch*, at the Institute of Contemporary Art San Francisco. Aki and I met during the Portland Institute of Contemporary Art's *Time-Based Art Festival* exhibition, curated by Kristan Kennedy, in 2015. Our work was placed next to each other in a big open warehouse where Aki was showing with his longtime collaborator, the veteran experimental sound artist Akio Suzuki. Aki was there installing a large turntable, one of Akio's earlier sonic inventions. Sadly, the elder artist was stuck outside

the country, in Japan, hamstrung with visa issues. Aki would do it alone. Damn borders! I was showing *Surface Contents*, a large video projection mapping the value of the warehouse in gold dust. Mine was silent; theirs audible—both circular patterns revolving in time. Kristan, as she is wont to do, found a great match! In New York months later, I finally encountered Akio and Aki performing together at ISSUE Project Room's temporary location in SoHo. I was delighted to find that Aki had taken one of my gold thermal blankets, a performative giveaway from the Portland show, and was using it here for sound. Aki must have been drawn to the crinkly sonic potential of the Mylar, just as I had been drawn to its inherent sculptural mutability and color.

RAVEN CHACON

Raven Chacon just won a Pulitzer. His work seems to be everywhere right now, and I have to say it couldn't happen to a more talented artist and nicer guy. I first encountered Raven's work in the collaborative *Postcommodity*, whose video installation *A Very Long Line* stood out in the 2017 Whitney Biennial. Academic and writer Sampada Aranke introduced us when she was touring around New York with me and my grad students from Portland. The *Postcommodity* trio

met with my class up on the High Line, and we had a drink afterward. For an educator, these conversations with artists are what it's all about.

I bumped into Raven several times following that initial encounter, including at a party at María Elena González's apartment in Brooklyn. He was the quietest of the *Postcommodity* artists, holding more in presence than in chatter. In spring 2021, Raven, along with tireless curator Diego Villalobos, staged *Radio Coyote*—a local radio broadcast and internet station from the Wattis Institute for Contemporary Arts in San Francisco, part of California College of the Arts, where I am currently faculty. It was still deep pandemic times, so the gallery was closed, but the airwaves were active with Raven's many collaborators: sound artists, Indigenous communities, and thematic musical programming. I listened in to the stream often from my studio. We got to hang out one perfectly sunny afternoon at Roshy Kheshti and Salar Mameni's hillside Berkeley patio with drinks and delicious food made by Roshy's mom. Roshy writes about music, queerness, diaspora, and race, and is an old colleague of Raven's wife, the curator and writer Candice Hopkins. Later I reached out to Raven to rebroadcast *Radio Coyote* over Pyrite Radio. He told me *Radio Coyote* continues now

under the direction of the curatorial platform Atomic Culture, out of Tulsa. Fortunately, Raven and Atomic Culture each offered me a set for Pyrite Radio, for which I am especially grateful, given the scope and synchronicity of the project and Raven's many commitments and accolades.

ANDRES FREYRE AKA XOLO

I listen to the radio. Lots of it. Often while working in my studio, making food, or just hanging out. It always seems to be on. NTS Radio has been an endless source of music and discovery. By now I am familiar with many of the DJs and scour the stream of endless genres: electronic and house, R&B and hip-hop, experimental jazz and Hong Kong balladeers. I was particularly drawn to the show *La Cosecha Internacional*, whose DJs play a mix of vintage recordings from Mexico and beyond that have the tinsel rhythmic quality of lo-fi radios echoing out of any cornerstone of backyard gathering. I reached out to Andres Freyre, who goes by the DJ name XOLO and runs this show, knowing this sound would play seamlessly over my rudimentary radio's speakers and broken transmissions. Andres wrote right back and was enthusiastically in! We included his *Sonido*

Tijuanese show in the project. It's an absolute favorite of mine and seems like I built the radios with it in mind. I had spent some time in his native Tijuana, where I was hosted by Sergio de la Torre at the residency Lui Velazquez in the early 2000s while working with Lucía Sanromán on a show for the Museum of Contemporary Art San Diego. These connections and friendships remain significant to this day, as do the memories of the clanking border gate audible from the residency's spare quarters and the many tacos digested daily. More recently, in March 2022, I was asked to perform at the 18th Street Arts Center, in Santa Monica, and I invited XOLO to spin records live while broadcasting over my radios. It was a thrill to meet in person, and even his eleven-year-old son joined in, dropping vinyl on the turntables and chatting up our friends. Andres was keen to offer this bio, which sums up his work aptly: "Inspired by quinceañera parties in the hills of Mexico and beyond and rooted in partying as a form of immigrant resistance. *La Cosecha* was started by XOLO. Playing all Spanish, all vinyl norteñias, corridos, rancheras, cumbia, and banda classics. XOLO's aim is to bring this music to a new generation."

Reading Lorraine O'Grady's 2009 account of *The Black and White Show* (1982) opened a mode

to consider an artist's practice and curatorial project as intermingled and dependent on the layered relationships that form an "art world." These narratives expose not simply the contents of an objective curatorial agenda but also the often-subjective happenstance sympathies and challenges of community from which this hybrid work arrives. The slippery role of the artist/curator/organizer/collaborator likewise exposes a structural condition of making a life in art that is not independent but reliant on others, holding mutuality and complexity together in the myriad ways it all comes together.

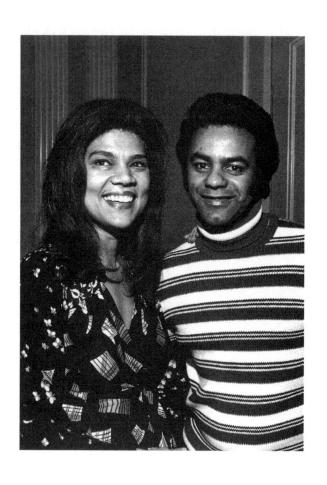

"In Our Lives": Lorraine O'Grady and Johnny Mathis at a Record Release Party
by Jacqueline Francis

There's a black-and-white photo of Lorraine O'Grady and Johnny Mathis taken at the after-party of the singer's concert in New York on January 24, 1974.[1] Although the two were meeting for the first time, the body language suggests that they were immediately at ease in each other's company: Mathis's right hand drops behind O'Grady's back, and the fingers of her left hand rest upon his shoulder. Both are smiling. O'Grady's gaze is sidelong, likely directed at someone who has momentarily grabbed her attention. Mathis looks directly at the camera, for he has quickly readied himself for the photographer's shot. A star high school and college athlete and a crooner who developed a fan base in the 1950s, Mathis was well acquainted with celebrity. O'Grady was not. She was at a crossroads.

In the late 1960s, O'Grady had a successful career as a translator for *Encyclopedia Britannica* in Chicago and also studied fiction writing at the renowned Iowa Writers' Workshop. She then

moved to New York in the 1970s and became a music critic and taught courses on Dada and Surrealism at the School of Visual Arts. For many years, the latter job held her interest and sustained her with a paycheck; the former provided neither, and she quit in short order.

The early 1970s was a critical time for Mathis, too. His signature songs—sentimental ballads and upbeat musical theater and film tunes—differed from the soul and rock 'n' roll genres that dominated the charts. While he was prolific in his output, sometimes releasing two albums in a single year, and toured constantly, his sales were far from robust. In a radio interview just before the January 24 concert, he disclosed that the stress of performing, combined with his workload and self-doubts, had led to a reliance on prescription drugs, namely "pills to get up and pills to go to sleep."[2] He was thirty-eight years of age at this point, and looking back on his youth, he noted that he had gotten "rid of the reasons to hide—whatever they were. I never really did find out. But I'm at least comfortable in front of the public. Well, sort of. I don't think I'll ever be the type of public person that I really, I guess—that I am supposed to be."[3]

Mathis was living in a glass closet.[4] That

is, long before the 2017 television interview in which he unequivocally stated that he was gay, Mathis was widely read as queer.[5] I remember my mother, a Mathis fan, casually conveying this information to me sometime during the 1970s when she called him a "poor thing." There was pity in her voice. To her, Mathis, universally acclaimed and rewarded for his talents, was a failed man. My mother also meant to impress upon me—a preteen girl pushing against heteronormativity—that nonconformity and others' awareness of it had consequences. Shame was the greatest of them, and it was to be avoided at all costs.

If in 1974 Mathis had much to lose, O'Grady felt that she had little. Assessing her conservative upbringing and elite education, she had concluded that they prepared her for a life she did not want. To figure out how to be an artist, she immersed herself in a number of New York art communities. She took risks, and ultimately exhorted others to do so as well in her best-known performance work, *Mlle Bourgeoise Noire* (1980–83). Recalling the evening during which she was photographed with Mathis, O'Grady told me that they were both "just in our lives."[6] This phrase is fulsome, arguably more so than the photo. The picture—a single, frozen

moment—cannot match the plural, interior, and expansive qualities borne by the words. They hum with O'Grady's memory of being and doing—her own and her sense of Mathis's.

Notes

1 Some sources date this photo to January 24, 1973, but it was most likely taken in 1974, as Mathis was performing at New York's Avery Fisher Hall on January 24, 25, and 26 of that year. These concerts were listed in the press; for example see *New York* 7, no. 3 (January 21, 1974): 16.
2 Richard Pyatt, interview with Johnny Mathis, New York Public Radio Archives, circa January 1974, available at https://www .wnyc.org/story/johnny-mathis/. Later in this interview, Mathis speaks about cigarette and alcohol use.
3 Pyatt, interview with Johnny Mathis.
4 *Merriam-Webster* defines this as "the state in which the sexual orientation or gender identi- ty of an LGBTQ individual is known to many but not publicly acknowledged," and dates its origin as 1974. https://www.merriam-webster .com/dictionary/glass%20closet.

5 Nancy Giles, interview with Johnny Mathis, CBS News *Sunday Morning*, May 14, 2017, available at https://www.cbsnews.com/video /web-extra-johnny-mathis-on-coming-out/. In 1982, Mathis, in an interview he thought was off the record, stated: "Homosexuality is a way of life that I've grown accustomed to." Vincent Stephens, "Shaking the Closet: Analyzing Johnny Mathis's Sexual Elusiveness, 1956–82," *Popular Music and Society* 33, no. 5 (December 2010): 598.

6 Lorraine O'Grady, telephone interview with the author, May 4, 2022. I am grateful for O'Grady's generosity.

Rock, Racism, and Retailing 101
by Darrell M. McNeill

Birth of a Phenomenon:
The Roots of Rock Music

The Swing Era died out at the end of World War II, as it was no longer economically viable for venues to support huge orchestras. Ballrooms closed and most of the big bands broke up.[1] Smaller combos and more intimate clubs, notably on the jazz circuit where the "be-bop" sound was born, were on the rise. Other black artists found their niche by returning to the blues or, rather, "jumping the blues." Eliminating horn and string sections and emphasizing the rhythm section forged a new aggressive sound that swept over black communities across the nation.[2] By 1949 *Billboard* formally designated it as "rhythm and blues," a term devised by staffer-turned-legendary-record-man and R&B producer Jerry Wexler.[3]

Key figures would emerge in this movement—Louis Jordan, Wynonie Harris, John Lee Hooker, Bo Diddley, Fats Domino, Dave

Bartholomew, T-Bone Walker, Johnny Otis, Big Mama Thornton, and Muddy Waters were but a few. Like the music, the singing and lyrical content was more bold, candid, uninhibited, and raw. Songs like "Open the Door, Richard," "Beans and Cornbread," "Caldonia," "Ain't Nobody Here But Us Chickens," "That's How You Got Killed Before," "Boogie Chillen," and "Good Rockin' Tonight" were becoming popular in major urban centers. And bands from Chicago, New Orleans, Los Angeles, Memphis, Kansas City, and New York each added their own hues to the rhythm and blues palette. Southern musicians in particular crossbred the instrumentation and dynamics of folk and country, which for their part borrowed heavily from the blues.[4]

The new style of music gave birth to a new style of radio. As television took over the national programming and ad revenues, radio focused on local and regional interests. The informal structure in place at the time allowed local disc jockeys, or "personality jocks," to dictate the tastes of the times.[5] They were recruited from the community and had their fingers on the pulse of what records would be successful. They married the kinetic language of the streets with the energy of the records. Hal Jackson, Jack Gibson, Professor Bop, Sugar Daddy, Eddie O'Jay, and

Jocko Henderson were some of black radio's pioneers.[6]

Later, white jocks copying black jock styles and play lists—most notably Arnie Ginsburg, Wolfman Jack, Stan Richard, Alan Freed, and Murray the K—came to national prominence.[7] Predictably, this was the talent pool for national shows, radio in big-market cities, and television, while black jocks made the most of local radio. Disc jockeys were the arbiters who made or broke records, and they wielded great power in rock's early days. (This was also a sticking point as the 1950s closed and radio's infamous payola scandals erupted.)[8]

But despite how the new sounds were winning fans, black artists were prevented from capitalizing on its growing popularity. It was standard practice for most record companies to flagrantly cheat talent of their publishing rights and record sales.[9] This spawned high artist turnover and fueled the industry's predisposition about breaking black performers through singles rather than albums.[10] Moreover, record companies began releasing records in 45-rpm and 33-rpm formats because of the higher fidelity (or "hi-fi") sound. But due to lack of money, most black households still had 78-rpm record players and it would be a few years before new ones became affordable.[11]

The primary encumbrance, however, was still the race question. Whereas brickbats over blues and jazz were confined to editorial pages, literary salons, and PTA meetings, this new rhythm and blues—this "race/devil music"—ignited the American-Christian-Anglicized equivalent of a jihad.[12] At the rabid height of the McCarthy era (the government-sanctioned witch hunt for communist activity during the Cold War) and apartheid rule of the Jim Crow South, rhythm and blues was an affront to aspirations of a white male homogeneous society.

The 1950s provided the right cultural, social, and political conditions for the emergence of a new musical form, a form rooted in rebellion and based on race. World War II veterans were returning from the war to start families en masse. This emphasis on family was to become a major theme of the decade. The family was the nexus for most activities in the culture at the time, or at least it was supposed to be. In the public sense, life was oriented around the family. Any sign of "dysfunction" was kept in private. Any deviation from the norm was identified and rooted out.[13]

Priests, politicians, pundits, and parents raised a deafening hue and cry, particularly in the southern states. Propaganda was

disseminated through all available media. Town hall and committee meetings, even congressional hearings were held. Antidancing laws and curfews were enacted. Protests and boycotts were organized. Bonfires for records, books, and all other materials deemed "subversive" became community events.[14] Northern states for the most part went through no such histrionics. Most of the North's urban centers—experiencing the explosion of US Afro-Americans from the South, and Afro-Caribbean and Latin American populace from the islands—were deep in the throes of white flight to suburbia. But in the extremely repressed climes of the suburbs, the new music form drew just as much enmity. Parties and dances devolved into police-baited riots. During the payola scandal of 1960, Massachusetts State Representative Tip O'Neill demanded that the Federal Communications Commission investigate all stations whose employees were involved in payola, convinced that the "captive audience" of American youth must be safeguarded from the demoralizing effects of payola and rock 'n' roll ("a type of sensuous music unfit for impressionable minds.")[15] Rock was, in the minds of "right-thinking Christian Americans," a bona fide threat to their way of life. And, for all intents and purposes, it was.

Birth of the Unseen Color Line:
Black Talent/White Faces

Historically, in order for "race music" to be embraced by whites, it had to be reinterpreted by white entertainers. Enterprising broadcasters, independent labels, and promoters had long recognized the commercial value in putting out "race music." Still, their success was limited to regional singles. With hostile racial environs and limited resources, they could not generate national hits based solely on the strength of their black talent. While *Billboard* began its rhythm and blues chart in 1949 and Jackie Brenston's "Rocket 88"—actually Ike Turner's band—would be the first national rhythm and blues hit to make the pop chart, it would be years before black artists achieved national recognition.[16]

Given the racial underpinnings of the rhythm and blues scene, it was plain that white performers stood to gain little going that route. But they could not call their music "pop" either—"pop" then was Bing Crosby, Doris Day, Perry Como, Frankie Laine, Jo Stafford, and Frank Sinatra.[17] The term "rock 'n' roll" (a euphemism for sexual intercourse) was lifted from several rhythm and blues releases to lend nomenclature to the hot new style. Alan Freed—anointed in mainstream

circles as the "Father of Rock 'n' Roll"—has been credited with coining the phrase in his broadcasts.[18] Thus yet another outlet was invented for white artists and entrepreneurs to exploit and profit from contemporary black music.

"If only I could find a White man who had the Negro sound and the Negro feel, I could make a billion dollars."[19] There is a reason why these words of Sam Phillips, owner of the legendary Sun Records label, resonate to this day. Because he did find his white man with the "Negro sound" (several, in fact) and he did make millions, if not a billion, and in his innocuous quip he laid out the blueprint for rock success. It was imperative for every savvy record man to find white artists who could give reasonable enough representation of "race music" without the attendant racial baggage. Bill Haley & His Comets would be the first white exposition of the "Negro sound" to spark the pop charts, and Elvis Presley later combusted them. Black artists took considerably longer to achieve such success (again, owing as much to limited indie resources as racially skewed marketing).

To illustrate, Bill Haley cracked Billboard's year-end Top 50, landing at the number 26 spot in 1954 with "Shake, Rattle & Roll" (a cover of the Big Joe Turner classic). The following

year he reached number 2 with his own classic "Rock Around the Clock," joined by Pat Boone at number 9 covering Fats Domino's "Ain't That a Shame." The first time black rock 'n' rollers—specifically Fats Domino, The Platters, Little Richard, and Frankie Lymon & The Teenagers—appear at all is in rock's watershed year of 1956—the year Presley began his chart reign. (He had five songs in the Top 50, including three in the Top 10.)[20]

But outside of The Platters, who scored number 4 with "My Prayer," no black artists would crack the Top 20. The first black non-balladeers to do so would be The Silhouettes in 1958 with "Get a Job" (number 14). The first black rock song to crack the Top 5—albeit with milquetoast vocal dubs and orchestra—was Lloyd Price's "Personality" in 1959. It would take until 1960, and Bobby Lewis with "Tossin' and Turnin'," for a black rock 'n' roll artist to reach number 1 on the year-end chart.[21] Presley, on the other hand, broke the Top 5 every year through the decade's end except for 1959 (when he was called up for a dubious two-year military hitch and could not record).

Throughout the modern rock era, black music has had to acquit itself with strong action on the rhythm and blues charts before it was

deemed worthy of pop or rock promotion and airplay. Just because a song was a big hit on the R&B charts was no guarantee of mainstream or "crossover" success. And since there was no separate "rock" chart then, white artists did not go through the same preliminaries—their material was shipped straight to pop.[22]

Major labels dipped their toes into the rock/ R&B pool, but only with white artists covering songs originally performed by black artists. Naturally, because of their advanced production and better distribution and promotion, the covers usually outsold the originals. Presley, Boone, Georgia Gibbs, The Crew Cuts, The McGuire Sisters, Ricky Nelson, and others had some of their biggest hits this way. Even long-established pop balladeers like Andy Williams, Perry Como, and Steve Lawrence got into the act.[23] By 1960 rock 'n' roll was officially out of the closet. Sadly, its black founding fathers and mothers were left inside.

Birth of Separate and Unequal Marketing: Post-Rock Revolution Entrenchment of Artist/Race Division

As the 1950s were defined by conservative entrenchment of the status quo, the 1960s were defined by radical change. Various political movements (civil rights, antiwar, feminism, black power) faced off against defenders of the status quo and, though sociopolitical and economic barriers continue to plague American infrastructure, the awkward steps toward an integrated society were being taken. Rock music would be both soundtrack and sounding board for the shift of a nation's consciousness, and the industry transformed at a breakneck pace.

To say that television revolutionized media would be an understatement found wanting; it completely metamorphosed American life. While radio catapulted the music industry into another stratosphere, television would transport it to a different universe: In the 1950s, a gold record (500,000 units sold) was a profound benchmark; in the 1960s, television made million sellers a common occurrence. Shows like *Ed Sullivan*, *American Bandstand*, *Shindig*, and *Your Hit Parade* became premier showcases for rock talent.[24]

Radio underwent its own fundamental changes, though under acrimonious circumstances. In 1960 the Senate held hearings about "payola," the practice of bribery to get disc jockeys to put songs in rotation. To no one's real shock, payola was revealed to be the lay of the land. The laws were so weak and remedies so nominal that the payola bugaboo resurfaced in the 1970s and 1980s; some argue it still has a hand in the industry today.[25] Of greater import was the shift in the balance of power: jocks could no longer select records for air. That responsibility was transferred to the program director. This, in essence, was the beginning of the end of the personality jock and the beginning of specialized format radio. These formats proliferated as the technology for radio's frequency modulation band (FM) improved to the point where stereo broadcasts were possible, making it the ideal signal for music. FM became the standard and created new markets, multiplying revenues exponentially.[26]

Until the 1960s, most major record labels were still keeping black/rock music at arm's length—if they engaged it at all, it would be through subsidiary labels or distribution/buyout deals. So several of the independents that came in on the ground floor became serious forces,

specifically Atlantic, King, Chess, Roulette, Stax, and, of course, Motown.[27] These labels rewrote all the rules about black artists, black music, and black people's stature in the music industry—for better and for worse, as time would prove.

Against this backdrop black music was able to flourish; black people in the music, however, were a different matter. Granted, it was no longer inconceivable that a black person could get a job in the music industry and make a decent living. Creatively, it was a Golden Age as legends in black music were at the height of their powers: James Brown, Aretha Franklin, Sly & the Family Stone, Jimi Hendrix, Curtis Mayfield, Otis Redding, Ike & Tina Turner, Sam & Dave, the entire Motown roster, and many, many others. And black performers cracked markets once thought unassailable. But the devil, as ever, was in the details.

Race-neutral facades camouflaged the reality that the commercial music industry was founded, structured, and, indeed, profited along segregationist patterns. Excepting the rare odd birds like Hendrix, Stone, the Turners, or Richie Havens, rock music became the exclusive domain of white artists. Black artists were relegated to rhythm and blues, whether their sound had any discernable difference from rock or not.[28]

In fact, rhythm and blues was further subdivided into yet another category: "soul music." While many a critic has burst many a synapse trying to parse together a plausible musical distinction, from a marketing standpoint it was not all that complicated.

Rhythm and blues was black music that could be crossed over and exploited in white markets; soul was black music that would go over only in the black community.[29] (This rationale proved specious in the 1970s as the purported "stylistic lines" between the genres blurred—plus, it turned out that white people also bought Otis Redding, Aretha Franklin, and James Brown records.)

The music business structure itself was (and is) segregated. Major labels established "black music divisions"—in-house staff employed to implement all strategies, whether with the label's own talent, or to monitor and broker activity with a label subsidiary. These divisions, by and large, ran on a tight leash, had limited resources, and, if an act managed to become successful enough to cross over, the pop division took over.[30] Moreover, since labels labored under the notion that black artists' commercial value lay in singles rather than in albums, they were shackled creatively. Songs had to be "marketable" (i.e.,

instant hits), whereas white rockers were more free to experiment. This often resulted in black artists repeating formulas or, even worse, jumping on the successful style of the moment, whether it suited them or not.[31]

"Introducing artists and material to the market, the label seeks the most cost-effective forms of hit-making. Historical US models of racism and racial polarization, while shunned in intellectual discourse, are pervasive in every aspect of American culture—including commerce" noted marketing specialist Kimberly Steger in a survey of non-traditional black artists. "With few exceptions, the music of black pop artists is lumped into a category called 'black music,' both within the industry and casually by consumers. For the purposes of marketing, the label often separates the stylistic offerings of nontraditional black artists from their ethnicity. While the corporate gatekeepers may be sold on the content produced by the artists, the historical model is one based on racial alignment unless a track record has proven otherwise. While the artists relegated to the term 'black music' may offer works ranging from jazz vocals to thrash rock, the traditional model of R&B remains the traditional style associated with black artists. Industry and cultural investment in this concept prohibits

proper marketing campaigns and anchors the potential of diversifying marginalized voices as well as creating new musical markets."[32]

And despite slight improvements in contract law, most black artists still got fleeced in onerous record deals.[33] In 1994 the Rhythm & Blues Foundation was established. It funded the Atlantic Foundation and other music industry organizations to aid destitute rhythm and blues performers of the early rock era whom the *New York Times* characterized as "victims of poor business practices, bad management and unscrupulous record companies."[34]

Media segregation took on farcical proportions. Radio's specialized formats—album-oriented rock (AOR), country, Top 40/contemporary hit radio (CHR), and urban (code language for black)—further codified racial separation by genre. It also enabled advertisers to target specific audiences and demo groups. This has long been a source of great ire for black—or rather "urban"—stations because it gives ad buyers an escape hatch for not spending money with them or billing at lower rates than so-called general market (i.e., white audiences) stations without drawing accusations of overt racism.[35] This pattern was consistent in urban television, public relations, and print media as well.

Black programmers and audiences also contributed this schism. In *The Death of Rhythm & Blues*, critic Nelson George details the class and ideological rifts that shaped the black marketplace: privileged-class blacks who wanted no truck with the culture of their working-class or poor brethren; conservatives repulsed by hippie and/or radical culture; embittered separatist elements within the Black Power movement who fomented distance from white popular culture (even if it embraced, copied, or adopted theirs); cooler-than-thou hipsters who equated white with "corny."[36]

Cultural scholar William Benzon wrote in his landmark essay, "Beethoven's Anvil": "Frameworks of ethnic and national identity set up social boundaries. Even as memes migrate across these boundaries to serve people's emotional and physical needs, thereby reducing differences between groups, the need to maintain boundaries asserts itself. It also results in new musical styles, and black Americans continue to create music they can think of as specifically theirs. This is the mechanism that has been driving American culture through the twentieth century and into this one."[37]

It also bears repeating that the three largest major recording companies—CBS, RCA,

Warner Brothers—did not bother with black rhythm and blues/rock performers in any significant way until some twenty years after the market for them had established itself and independents threatened to render them irrelevant. (Decca and EMI-Capitol beat the other majors by about two decades.)[38] When they finally penetrated the market, they did so with extreme prejudice—in every sense of the term. The majors, with near-monopoly control over the distribution network, kept the indies at bay up to a point. After all, they were getting a piece of whatever product was shipped.[39] What stuck in their craw was how much of the overall market share the baby labels commanded: As a genre, rock 'n' roll jumped from 15.7 percent of the market in 1955 to 42.7 percent in 1959. As a result of the popularity of rock 'n' roll, sales industry-wide grew from $213 million in 1954 to $603 million in 1959. From 1948 to 1955, the number of firms (as opposed to labels, since many labels can be owned by a single firm) that posted hits in the Top 10 ranged from four to seven. But from 1956 to 1959, this number rose to twenty-nine. For a brief time span, the majors lost half of their market share to independent labels.[40]

To "rectify" this disparity, majors consolidated with independent labels at furious pace, with the number of label-owning firms cut in half between 1960 (forty) and 1971 (twenty).[41] (CBS was particularly noteworthy because it actually commissioned a university study—the now-infamous Harvard Report—on how to penetrate the marketplace.) Some labels folded by attrition. Others were bought outright or squeezed out. By the mid-1980s, even the two biggest players on the black music scene—Stax and Motown—were no longer factors. Stax was shuttered in 1975 by overwhelming debt and a rancorous legal battle with CBS.[42] Motown, after an uneven foray into the film business, was unable to keep its premier talent, keep pace with the music of the times, or handle the costs of running a major label. MCA bought it out in 1988.[43]

The 1980s and 1990s served as a time of entrenchment for major label formulas and continued consolidation. Majors merged with or bought out other majors, then multinational conglomerates bought them out. To date, there are only five major music distribution firms on the planet: EMI Distribution, Sony Music, Vivendi/Universal, Bertelsmann Music Group (BMG), and AOL Time Warner. In 2001 these

companies posted about $40 billion in total sales.[44]

And while black music has gone through various permutations in the rock era—funk, disco, fusion, hip-hop, reggae, house, et al.—not one single black rock artist has cracked the *Billboard* year-end Top 50 since 1994, when Prince did with "The Most Beautiful Girl in the World," a middle-of-the-road R&B ballad.[45] Rock music in general has not enjoyed as active a presence on the charts in the last decade or so, but black rockers have been practically invisible, with sparse appearances by Prince (1983–1987, 1989, 1992, and 1994) and The Isley Brothers (1963, 1973).[46]

Birth of an Epilogue

Rock 'n' roll adopted countless styles and spawned countless legends from its birth sixty years ago, but it is still the most popular form of music across the globe to this day. Sadly, there is also still a great deal of cultural apartheid in the music industry. Its originators—the great blues men of the 1920s, 1930s, and 1940s—have been all but forgotten. Its innovators—Little Richard, Chuck Berry, Fats Domino, LaVern Baker, The Isleys—while honored, have been largely relegated to footnote status within the context of their aggrandized white peers. Despite the obvious rock underpinnings of later artists—Sly and the Family Stone, Curtis Mayfield, Aretha Franklin, Otis Redding, Parliament-Funkadelic, Rufus & Chaka Khan, Stevie Wonder, Prince, and countless others—black artists continue to play second banana to white artists. It is a pattern that continues today with black rockers like Ben Harper, Fishbone, Living Colour, Me'Shell NdegeOcello, David Ryan Harris, Terence Trent D'Arby, Weapon of Choice, Kina, Martin Luther, Skunk Anansie, King's X, Seal, Tracy Chapman, and legions more.

"The distribution of nontraditional black pop artists is challenging due to historical models

built on segregation, black nationalism and racial politics, poor marketing campaigns, and the economics of niche marketing to the masses," Steger continues in her survey. In spite of the success of artists such as Lenny Kravitz, Living Colour, and Macy Gray, many nontraditional black acts will not find an audience due to the above-mentioned conditions. For the distribution of music to expand past a system predicated on race, more than talented artists with quality work must come to the marketplace. Our current system of marginalizing content based on race continues the historical model, even if cultural preservation is touted as a motivating factor. The demand does exist for quality work, regardless of ethnicity. What is needed is capital investment in the infrastructure of distribution that is sensitive to altering the color-coded system.[47]

Racist attitudes continue to hamper intelligent dialog about rock's origins and black artists getting their due. While Presley, Haley, Carl Perkins, Jerry Lee Lewis, the Beatles, the Rolling Stones, Janis Joplin, and others have long acknowledged their debt to rock's black pioneers and visionaries, the music industry and mainstream media are unwavering in making them ride the back of the bus—as if everything Presley, Haley, Perkins, Lewis, et al. did

manifested fortuitously. While rock's musical roots can be traced back to the days of slavery and sharecropping, it seems ironic that a genre that so symbolizes freedom and liberation is curated with attitudes that can be traced back to the same era.

Notes

1 Reebee Garofalo, "Crossing Over: From Black Rhythm & Blues to White Rock 'N' Roll," in *Rhythm & Business: The Political Economy of Black Music*, Norman Kelley, ed. (Brooklyn, NY: Akashic Books, 2002), 116–17.

2 Garofalo, "Crossing Over," 117–19; Mel Watkins, *On the Real Side* (New York, NY: Simon & Schuster, 1994), 334–38.

3 Fredric Dannen, *Hit Men* (New York, NY: Vintage, 1991), 87.

4 Garofalo, "Crossing Over," 117–18; Watkins, *On the Real Side*, 334–38.

5 Garofalo, "Crossing Over," 120.

6 Garofalo, "Crossing Over," 120–21; Watkins, *On the Real Side*, 294–97.

7 Garofalo, "Crossing Over," 121; Watkins, *On the Real Side*, 295–96.

8 Garofalo, "Crossing Over," 120; Dannen, *Hit Men*, 44–45.

9 Garofalo, "Crossing Over," 122–23; Dannen, *Hit Men*, 31, 34.

10 Garofalo, "Crossing Over," 122–23.

11 Garofalo, "Crossing Over," 127–28.

12 Watkins, *On the Real Side*, 338–39.

13 John Bulmer, *Devil Music: Race, Class, and Rock and Roll* (Albany, NY: Russell Sage College Press, 1997).

14 Watkins, *On the Real Side*, 338.

15 Charles William White III, "Payola Scandal Timeline," *The Beat* (1985).

16 Billboard, Top 50 Lists (1951–2001).

17 Garofalo, "Crossing Over," 116.

18 Garofalo, "Crossing Over," 121; Dannen, *Hit Men*, 42–43.

19 Sam Phillips quoted in Peter Guralnick, *Feel Like Going Home: Portraits In Blues and Rock 'n' Roll* (New York, NY: Outerbridge and Dienstfrey, 1971), 140.

20 Joel Whitburn, *Billboard Top 1000 Singles* (1955–2000): *1000 Biggest Hits of the Rock Era* (Milwaukee, WI: Hal Leonard, 1997), 34–39.

21 Whitburn, *Billboard Top 1000 Singles*.

22 Fred Goodman, *The Mansion on the Hill* (New York, NY: Vintage 1998), 137; The National Association for the Advancement

of Colored People (NAACP) Economic Development Department, 1987 Report, "The Discordant Sound of Music: A Report on the Music Industry," in *Rhythm & Business: The Political Economy of Black Music*, 46–47.

23 Garofalo, "Crossing Over," 124–126.

24 Halberstam, *The Powers That Be*, 130; Garofalo, "Crossing Over," 120; Dannen, *Hit Men*, 34, 46–47.

25 Dannen, *Hit Men*, 45–47, 109.

26 Goodman, *Mansion on the Hill*, 36–40, 142.

27 Garofalo, "Crossing Over," 118.

28 Dannen, *Hit Men*, 11, 87.

29 Samuel A. Floyd, *The Power of Black Music* (New York, NY: Oxford University Press, 1995), 203–06.

30 NAACP 1987 report in Kelley, *Rhythm & Business*, 46–47; Garofalo, "Black Popular Music; Crossing Over or Going Under?," in *Rock and Popular Music: Politics, Policies, Institutions* (London: Routledge, 1993).

31 Nelson George, *The Death of Rhythm & Blues* (Pantheon, 1988), 150–53.

32 Kimberly Steger, "The Business of Stereotyping Black Music: The Stranglehold on Non-Traditional Black Artists in Pop Music," Fall 2001 report commissioned by Media Industry Perspectives, 4.

33 Garofalo, "Crossing Over," 122–23; Dannen, *Hit Men*, 31, 34.

34 Norman Kelley, "Notes on the Political Economy of Black Music," in *Rhythm & Business*, 14.

35 George, *Death of Rhythm and Blues*, 159–60;

36 George, *Death of Rhythm and Blues*, 68–69; LeRoi Jones (Amiri Baraka), *Blues People* (New York, NY: Perennial, 1963), 160–65, 233–36.

37 William Benzon, *Beethoven's Anvil: Music In Mind and Culture* (New York, NY: Basic Books, 2001), 273.

38 Garofalo, "Crossing Over," 118; Dannen, *Hit Men*, 31; Michael Roberts, "Papa's Got a Brand New Bag: Big Music's Post-Fordist Regime and the Role of Independent Music Labels," in Kelley, *Rhythm & Business*, 36.

39 Roberts, "Papa's Got a Brand New Bag," 31–32, 37–38; George, *Death of Rhythm and Blues*, 147–49; Garofalo, "Crossing Over," 118.

40 Roberts, "Papa's Got a Brand New Bag," 36.

41 Roberts, "Papa's Got a Brand New Bag," 36.

42 David Sanjek, "Tell Me Something I Don't Already Know: The Harvard Report on Soul Music Revisited," in Kelley, *Rhythm and Business*, 69–72; Rob Bowman, *Soulsville*

U.S.A: The Story of Stax Records (New York, NY: Schirmer Books, 1997), 277–371.

43 Berry Gordy, *To Be Loved: The Music, The Magic, The Memories of Motown* (Headline, 1994), 389–98.

44 Roberts, "Papa's Got a Brand New Bag," 36–37; RIAA press release, 2001 Consumer Profile, April 26, 2002.

45 Whitburn, *Billboard Top 1000 Singles*, 34–79.

46 Whitburn, *Billboard Top 1000 Singles*.

47 Steger, "Business of Stereotyping Black Music," 15.

For Opacity
by Édouard Glissant

Translated by Betsy Wing

Several years back, if l made the statement, "We demand the right to opacity," or argued in favor of this, whoever I was speaking to would exclaim indignantly: "Now it's back to barbarism! How can you communicate with what you don't understand?" But in 1989, and before very diverse audiences, when the same demand was formulated, it aroused new interest. Who knows? Maybe, in the meanwhile, the topicality of the question of differences (the right to difference) had been exhausted.

The theory of difference is invaluable. It has allowed us to struggle against the reductive thought produced, in genetics for example, by the presumption of racial excellence or superiority. Albert Jacquard (*Eloge de la différence*, Éditions du Seuil, 1978) dismantled the mechanisms of this barbaric notion and demonstrated how ridiculous it was to claim a "scientific" basis for them. (I call the reversal and exasperation of self

barbaric and just as inconceivable as the cruel results of these mechanisms.) This theory has also made it possible to take in, perhaps, not their existence but at least the rightful entitlement to recognition of the minorities swarming through-out the world and the defense of their status. (I call "rightful" the escape far from any legitimacy anchored silently or resolutely in possession and conquest.)

But difference itself can still contrive to reduce things to the Transparent.

If we examine the process of "understanding" people and ideas from the perspective of Western thought, we discover that its basis is this require-ment for transparency. In order to understand and thus accept you, I have to measure your solidity with the ideal scale providing me with grounds to make comparisons and, perhaps, judgments. I have to reduce.[1]

Accepting differences does, of course, upset the hierarchy of this scale. I understand your difference, or in other words, without creating a hierarchy, I relate it to my norm. I admit you to existence, within my system. I create you afresh. —But perhaps we need to bring an end to the very notion of a scale. Displace all reduction.

Agree not merely to the right to difference but, carrying this further, agree also to the

right to opacity that is not enclosure within an impenetrable autarchy but subsistence within an irreducible singularity. Opacities can coexist and converge, weaving fabrics. To understand these truly one must focus on the texture of the weave and not on the nature of its components. For the time being perhaps, give up this old obsession with discovering what lies at the bottom of natures. There would be something great and noble about initiating such a movement, referring not to Humanity but to the exultant divergence of humanities. Thought of self and thought of other here become obsolete in the duality. Every Other is a citizen and no longer a barbarian. What is here is open, as much as this there. I would be incapable of projecting from one to the other. This-here is the weave, and it weaves no boundaries. The right to opacity would not establish autism; it would be the real foundation of Relation, in freedoms.

[...]

The opaque is not the obscure, though it is possible for it to be so and be accepted as such. It is that which cannot be reduced, which is the most perennial guarantee of participation and confluence. We are far from the opacities of

Myth or Tragedy, whose obscurity was accompanied by exclusion and whose transparency aimed at "grasping." In this version of understanding the verb *to grasp* contains the movement of hands that grab their surroundings and bring them back to themselves. A gesture of enclosure if not appropriation. Let our understanding prefer the gesture of giving-on-and-with that opens finally on totality.

[...]

We clamor for the right to opacity for everyone.

Translator's Note

1 *Comprehension* could, of course, be translated as "comprehension" to point out the *mot* connection with the French word *comprendre*, which l have earlier rendered as "to grasp" or, when the sense is mechanical, as "to comprehend" (and once, at Glissant's behest, as "to integrate"). In American English, however, the controlling attitude implied in this particular instance, vis-à-vis other people or cultures, is more apparent in understanding than in comprehension.

INDEX

1
Dust jacket

The image on the dust jacket is
Yétúndé Olagbaju's *For Edmonia*,
2020. It is a color screen print, 20 × 16
inches. Courtesy of the artist.

2
Introduction
by Jacqueline Francis
and Jeanne Gerrity

3
Drive My Car
by 許芃 (Hsu Peng) and
Allison Yasukawa

This work was commissioned for
this publication and is previously
unpublished.

4
Say Translation Is Art
by Sawako Nakayasu

This text is an excerpt from *Say
Translation Is Art* (Brooklyn, NY:
Ugly Duckling Presse, 2020),
© Sawako Nakayasu.

5
Migrants' Routes, Ties, and Role
in Empire, 1850s–1920s
by Lara Putnam

This text is an excerpt from *Radical
Moves: Caribbean Migrants and the
Politics of Race in the Jazz Age* by Lara
Putnam. Copyright © 2013 by the
University of North Carolina Press.
Used with permission of the publisher
(www.uncpress.org).

6
Ghost Prints of Loss
by Trina Michelle Robinson

These works, 2022, are relief prints
on newsprint with ink made from
soil collected in Casamance, Senegal;
charred cedar from a border crossing
between Senegal and The Gambia;
bone black dry pigment; and etching
transparent base. Courtesy of the artist.

Many thanks to Meghan Smith for
pointing us to this artist's work.

7
Porous Records
by Bec Imrich

This work was commissioned for
this publication and is previously
unpublished.

8
Untitled (Aug 1, 2017)
by E. Jane

This text is an excerpt from the
chapbook *Deluxe Dreams or while
hiding away I still think of the world
while trying to love myself* (Portland,
OR: home school and Container
Corps, 2019). Courtesy of the artist.

9
Glitch Refuses
by Legacy Russell

This text is an excerpt from *Glitch
Feminism: A Manifesto* (Verso, 2020).
© 2020 Legacy Russell. Reproduced
with permission of the Licensor
through PLSclear.

10
Remnants, Portals, and Power: The Space I Am In
by Alisha B Wormsley

These images, 2022, are stills from a two-channel video, accompanied by text written by the artist. All work courtesy of the artist.

11
Laure of *Olympia*: A Revision of Precedent
by Denise Murrell

This text is an excerpt from *Posing Modernity: The Black Model from Manet and Matisse to Today* (New Haven, CT: Yale University Press, 2018). © 2018 by The Trustees of Columbia University in the City of New York.

Many thanks to Kim Nguyen for pointing us to this text.

12
Under Construction
by Camille Chedda

This work, 2017, is charcoal on paper, 42 × 48 inches, and is published courtesy of the artist. ©Camille Chedda, www.camillechedda.com.

13
Swallow the Fish
by Gabrielle Civil

This text is an excerpt from Gabrielle Civil's memoir and is published courtesy of the artist.

Many thanks to Allison Yasukawa for pointing us to this artist's writings.

14
From Me to Them to Me Again: Text in Three Parts to Accompany a Diptych Portfolio
by Lorraine O'Grady

This text is from the book *Saturation*, Snorton, C. Riley, and Hentyle Yapp, eds., pp. 155–58, © 2020 Massachusetts Institute of Technology, by permission of The MIT Press.

15
Destiny Manifested I, II, III, IV
by Charles Lee

These photographs, 2021–ongoing, are published courtesy of the artist.

Many thanks to Meghan Smith for pointing us to this work.

16
Optical Illusions: Images of Miscegenation in Nineteenth- and Twentieth-Century American Art
by Judith Wilson

This text is an excerpt, used with permission from University of Chicago Press, from "Optical Illusions: Images of Miscegenation in Nineteenth- and Twentieth-Century American Art" published in *American Art* 5, no. 3 (1991). Permission conveyed through Copyright Clearance Center, Inc.

17
Between That Event and This Memory: Tradition
by David Scott

This text is an excerpt from *That Event, This Memory: Notes on the Anthropology of African Diasporas in the New World* (University of Toronto Press, 1991). © The Zoryan Institute.

18
inner eye
by Erica Deeman

These photographs were commissioned for this publication and are previously unpublished. Courtesy of the artist.

19
Outline of *Black Athena*: The Afroasiatic Roots of Classical Culture Historiography and the Project as a Whole
by Martin Bernal

This text is an excerpt of "Introduction" in *Black Athena Writes Back*, pp. 1–20. Copyright 2001, Duke University Press. All rights reserved. Republished by permission of the copyright holder, and the Publisher. www.dukepress.edu.

20
empty, whole, and on the way
by Selam Bekele

This work was commissioned for this publication and is previously unpublished.

21
Linda Goode Bryant
by Rujeko Hockley

This is an excerpt of the interview *Linda Goode Bryant by Rujeko Hockley*, commissioned by and first published in *BOMB* on April 11, 2019, part of the The Oral History Project series. © Bomb Magazine, New Art Publications, and its Contributors. All rights reserved. The *BOMB* Digital Archive can be viewed at www.bombmagazine.org.

22
Museum Series
by Carrie Mae Weems

These digital c-prints are all dated 2006–present. Titles follow in order: *Guggenheim Bilbao*; *The British Museum*; *Galleria Nazionale D'Arte Moderna*; *The Louvre*; *Birmingham Museum of Art*; *Museum Island*; *Philadelphia Museum of Art*; *The Tate Modern*. © Carrie Mae Weems. Courtesy of the artist and Jack Shainman Gallery, New York.

23
Of Poets, Galleries, New York Passages
by Kathleen Collins

This short story is published in *Whatever Happened to Interracial Love?* © 2016 by The Estate of Kathleen Conwell Prettyman. Used by permission of HarperCollins Publishers.

Many thanks to Meghan Smith for pointing us to this text.

24
#BookReport
by Jeanne Finley and John Muse

This work was commissioned for this publication and is previously unpublished.

25
I Listen to the Radio _ A Catalogue of Encounters: Three Reflections on Collaboration
by Peter Simensky

This work was commissioned for this publication and is previously unpublished.

26
"In Our Lives": Lorraine O'Grady and Johnny Mathis at a Record Release Party
by Jacqueline Francis

This work was commissioned for this publication and is previously unpublished.

27
Rock, Racism, and Retailing 101
by Darrell M. McNeill

This text is an excerpt, used with permission of the author, from *Rip It Up: The Black Experience in Rock 'n' Roll* (London, UK: Palgrave MacMillan, 2004).

28
For Opacity
by Édouard Glissant

This text is an excerpt, used with permission of University of Michigan Press, from *Poetics of Relation* by Édouard Glissant, 1997, translated by Betsy Wing; permission conveyed through Copyright Clearance Center, Inc.

29
Sphinx Series
by Maud Sulter

These photographic prints, 1987, are courtesy of Harris Museum, Art Gallery & Library, Preston, England.

—

Every effort has been made to trace copyright holders and to ensure that all the information present is correct. If proper copyright acknowledgment has not been made, or for clarifications and corrections, please contact the publishers, and we will correct the information in future reprintings

Most texts retain the spelling and capitalization of the original publications

Is now the time for joyous rage?
(A Series of Open Questions, vol. 4)

Published by CCA Wattis Institute for Contemporary Arts
and Sternberg Press

Editors: Jacqueline Francis & Jeanne Gerrity
Design: Scott Ponik*
Editorial Assistant: Addy Rabinovitch
Proofreader: Vanessa Kauffman Zimmerly

Printed and bound by Friesens (Manitoba), in an edition of 1500
Printed on Glatfelter Exbulk 50 lb.
Set in Janson Text

ISBN 978-3-95679-659-3

Distributed by The MIT Press, Art Data, and Les presses du réel

This book, the fourth volume of the Wattis Institute's annual A Series of Open
Questions readers, is a result of a year of learning from the work of
Lorraine O'Grady in the company of research group members Kota Ezawa,
Jeanne Finley, Jacqueline Francis, Jeanne Gerrity, Bec Imrich, Michelle
Murillo, Kim Nguyen, Peter Simensky, Sam Vernon, Leila Weefur,
and Allison Yasukawa, with assistance by Zalika Azim and Selam Bekele.
Special thanks to Lorraine O'Grady, Ursula Davila-Villa, Page Benkowski,
and Meghan Smith.

© 2022 the editors, the authors, the artists,
CCA Wattis Institute, Sternberg Press

All rights reserved. No part of this publication may be reproduced or transmitted
in any form or by any means, electronic or mechanical,
including photocopy, recording, or any other information storage or
retrieval system, without prior permission in writing from the publishers.

CCA Wattis Institute for Contemporary Arts
360 Kansas Street
San Francisco, CA 94103
www.wattis.org

Sternberg Press
71–75 Shelton Street
London WC2H 9JQ
United Kingdom
www.sternberg-press.com

Robin Beard, Head of Installation and Exhibition Design; Niko Bellott, Senior
Director, Grants, Partnerships, and Engagement; Jeanne Gerrity, Deputy
Director & Head of Publications; Anthony Huberman, Director & Chief
Curator; Jacqueline Francis, Academic Engagement Coordinator; Carleigh
McDonald, Head of Membership & Individual Giving Director; Addy
Rabinovitch, Operations Coordinator; Meghan Smith, Curatorial Fellow; Diego
Villalobos, Exhibitions Manager; Justine Xi, Visitor Engagement Coordinator

Wattis Assistants: Katherine Hamilton, Alex Hwang,
Vicky Ng Feng, Yu Jin Sung

The CCA Wattis Institute program is generously supported by The Andy
Warhol Foundation for the Visual Arts, San Francisco Grants for the Arts; by
Leadership Circle members Katie and Matt Paige, Abby Turin and Jon Gans,
Lauren and Jamie Ford, Westridge Foundation, Mary and Harold Zlot; and by
Curator's Forum members. Phyllis C. Wattis was the generous founding patron.

This reader is the fourth volume of an annual publication series,
A Series of Open Questions.

*Following *Walking on Splinters*; published by Werkplaats Typografie, Arnhem,
the Netherlands, 2004; edited and designed by Marijke Cobbenhagen,
Joana Katte, Louis Lüthi, Janna Meeus, Radim Peško, Willi Schmid, and
Maxine Kopsa. Thanks to Anniek Brattinga, Armand Mevis, and Maxine Kopsa.

Printed in Canada

219

Sphinx Series
by Maud Sulter

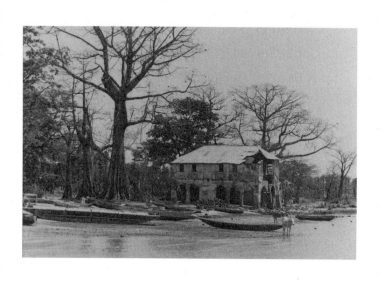